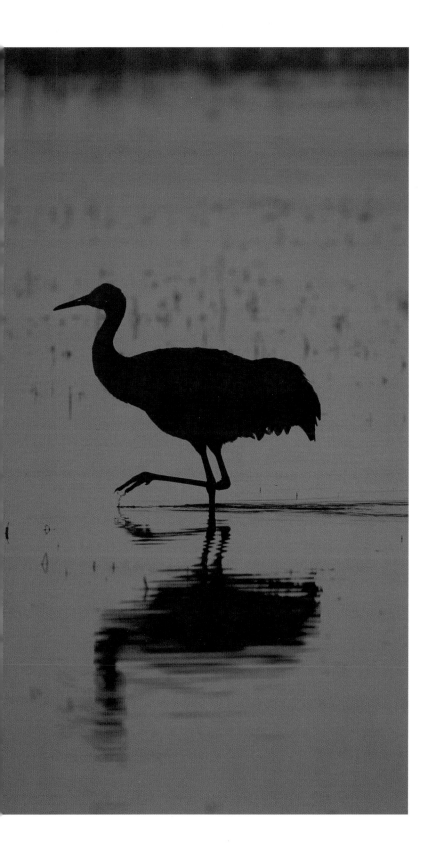

The Flight Deck
Digital Rhythms of Our National Wildlife Refuges

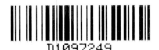

D1097249

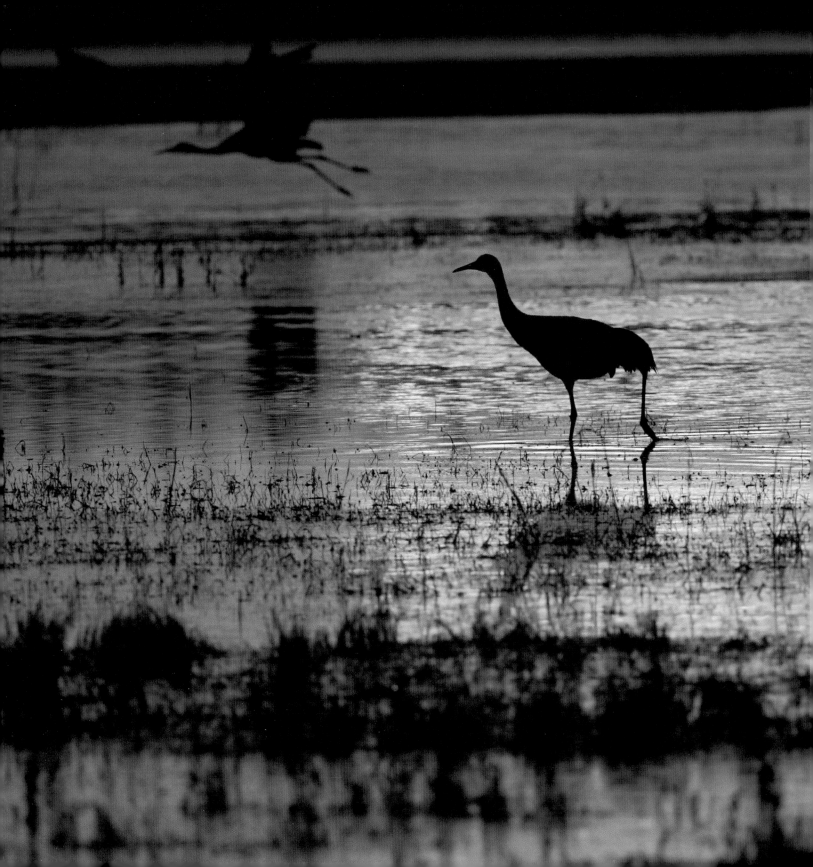

The Flight Deck
Digital Rhythms
of Our National Wildlife
Refuges

JIM JAMIESON

IMAGESTREAM PRESS
SAVAGE, MINNESOTA

Typeset in Adobe Garamond

First published in 2005 by ImageStream Press
8339 Carriage Hill Alcove
Savage, MN 55378
jjamieson@compuserve.com

For extra copies of this book please check with your preferred bookstore, or
write ImageStream Press.

Printed in China
by C & C Offset Printing Co., LTD.

Illustrations
Cover: Snow Geese, Bosque del Apache National Wildlife Refuge
Page 1: Sandhill Crane, Bosque del Apache National Wildlife Refuge
Page 2-3: Sandhill Cranes, Bosque del Apache National Wildlife Refuge
Page 124: Osprey, J.N. "Ding" Darling National Wildlife Refuge
Page 126: Snowy Egret, J.N. "Ding" Darling National Wildlife Refuge

This book is dedicated to my wife Julie, and sons Ian and Wesley whose endless
patience and understanding helped to make this work become a reality. Special
thanks to those who conserve and preserve our national park and wildlife refuge
systems.

In celebration of the 102nd anniversary of the U.S. Fish and Wildlife Service
National Wildlife Refuge System.

Publisher's Cataloging-in-Publication
(Provided by Quality Books, Inc.)

Jamieson, Jim, 1965-
 The flight deck : digital rhythms of our national
wildlife refuges / Jim Jamieson.
 p. cm.
 Includes bibliographical references.
 LCCN 2005901092
 ISBN-13: 978-0-9729126-2-4
 ISBN-10: 0-9729126-2-2

 1. Birds--Conservation--United States--Pictorial
works. 2. Photography of birds--United States.
3. National parks and reserves--United States--Pictorial
works. 4. Wildlife refuges--United States--Pictorial
works. I. Title.

QL682.J36 2005 598'.0973
 QBI05-200070

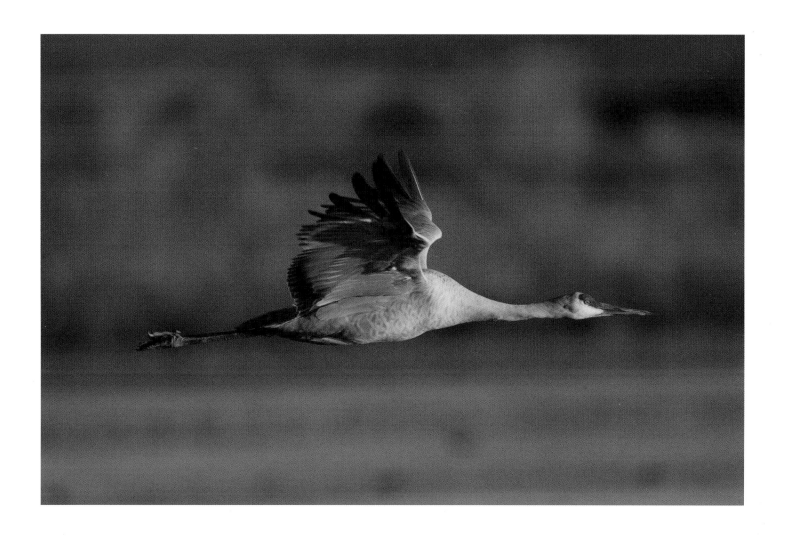

Sandhill Crane, Bosque del Apache National Wildlife Refuge

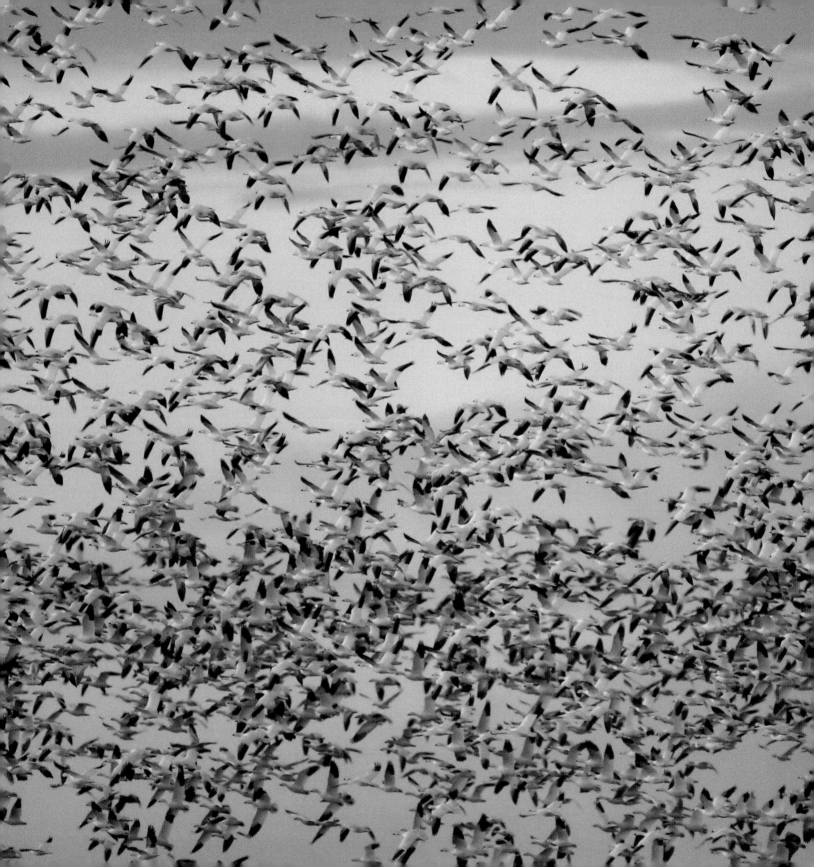

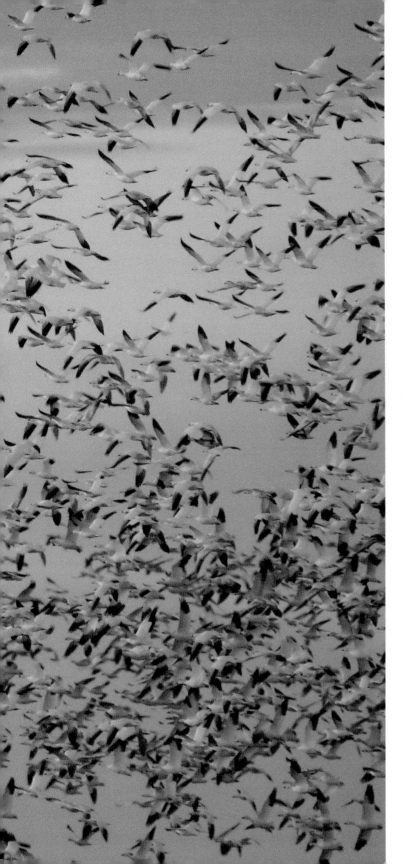

Contents

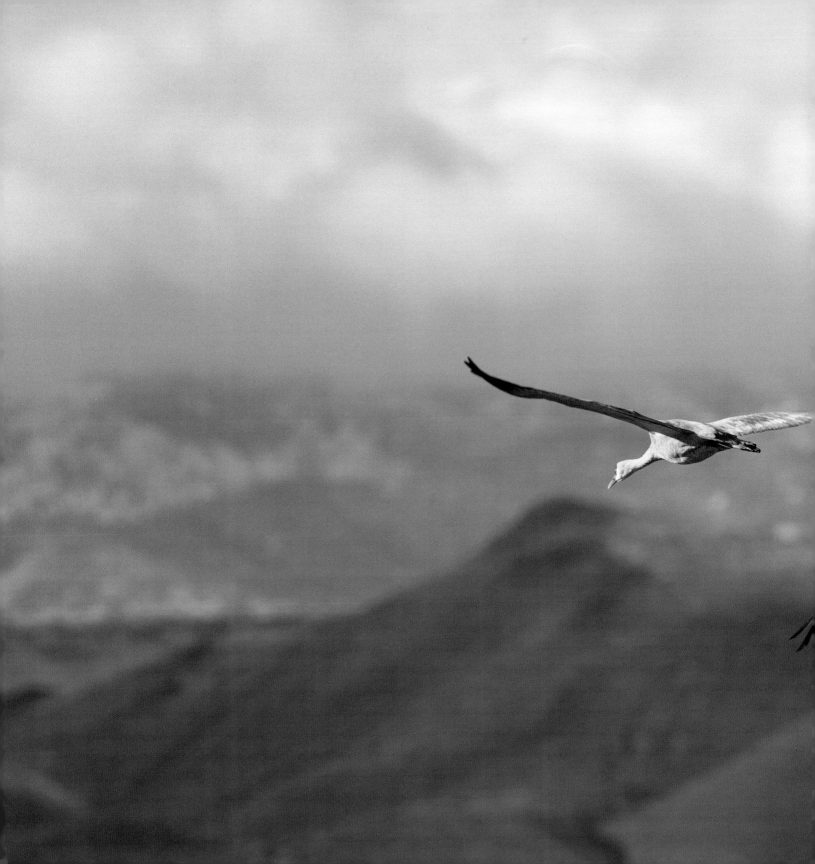

In

Introduction

Each year millions of birds stream across the autumn skies of northern breeding grounds to wintering locations in the southern United States and Central America. Returning along similar routes in the spring, this cycle has been repeated for thousands of years. As yearlings take their first flight, they follow their parents across this flight deck spanning thousands of miles of mountainous terrain, open grasslands, and waterways. The experience of migration is passed down from generation to generation. Food abundance, terrain features, seasonal conditions, weather, genetics, and family ties all contribute to the migration process.

Unraveling the mystery of migration continues to be a goal of wildlife biologists. As early as 1902, Dr. Paul Bartsch of the Smithsonian Institute placed numbered leg bands on 23 Black-crowned Night-Herons in one of the first recorded events to track the movement of birds. In subsequent years this work helped form the basis that international cooperation was needed to protect migratory birds.

Soon after Dr. Bartsch's study, on March 14th, 1903, President Theodore Roosevelt took the first step in preserving our wildlife by establishing the Pelican Island National Wildlife Refuge in Florida. The insightful protection of this small island sanctuary not only afforded highly endangered birds the security to thrive, it set in motion conservation and preservation efforts that have continued to this very day. Today, America's National Wildlife Refuge System comprises over 95 million acres in 540 dedicated refuges across the country. Operated by the US Fish & Wildlife Service, our National Wildlife Refuge System provides critical protection and preservation for a wide number of species.

While our National Parks and Wildlife Refuge systems were being established, in 1918 the United States entered into the Migratory Bird Treaty Act with Canada, Mexico, Japan, and the former Soviet Union for the protection of migratory birds. Under this Act, taking, killing, or possessing migratory birds is unlawful, establishing federal responsibility for migratory birds. Within the United States, the Secretary of the Interior has the authority to regulate the extent of hunting and other activities directly affecting migratory birds. These regulations are effective upon Presidential approval. Shortly after the passage of the Migratory Bird Treaty Act, which is still in effect today, a self-taught ornithologist from Colorado named Frederick Lincoln, joined the U.S. Bureau of Biological Survey and was assigned the task of organizing the Nation's bird banding program. Lincoln formed a continental bird banding program that also remains in effect today. By banding the legs of birds with a unique number in their breeding colonies and then recording the location where they were recovered, continental migration routes were unraveled. Today this activity is the responsibility of the U.S. Geological Survey, Patuxent Wildlife Research Center who organizes, collects, and analyzes migratory bird tracking information.

While bird banding had been occurring for a number of years prior, Lincoln's office helped to catalog and describe fully the migration of numerous waterfowl and other birds on a federal scale. In 1935, Lincoln issued two landmark documents, *The Waterfowl Flyways of North America* and *The Migration of North American Birds*. These findings categorized migration into four main routes, the Pacific, Central, Mississippi, and Atlantic Flyways. These pathways are not necessarily exact routes but general paths, often following key terrain features and waterways.

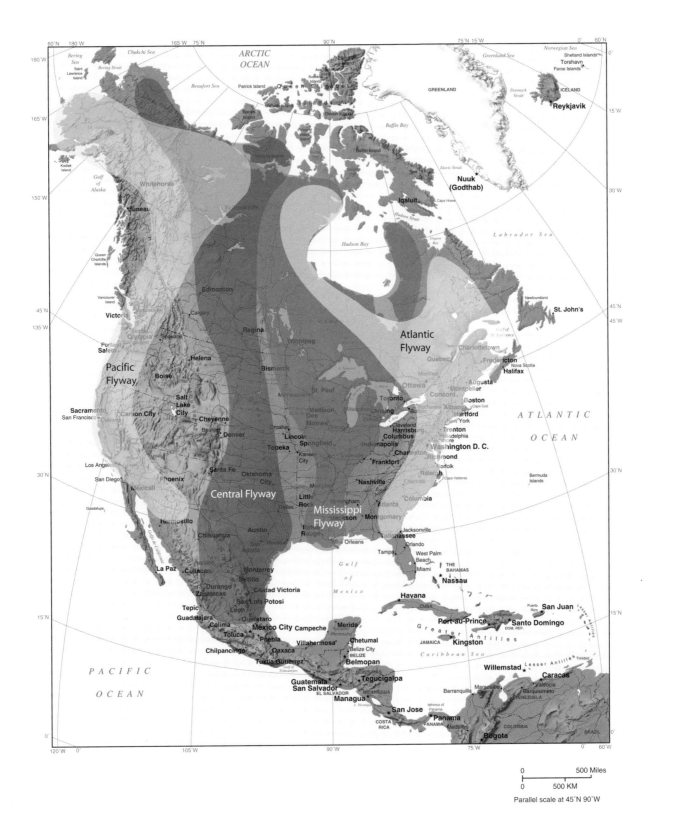

The Pacific flyway extends from the northern coastal extremes of the Aleutian Islands in Alaska to regions between the Pacific coast and the western side of the Rocky Mountain range in North America. In the southwestern United States, this migration route merges with the Central and Mississippi flyways continuing south into Mexico and Central America. The Central flyway extends from the northern interior and northwest territories of Alaska and Canada along the eastern side of the Canadian and US Rocky Mountain range. Approximately midway is the Platte River in central Nebraska. Here, hundreds of thousands of birds stage in the abundant water and farmlands of the midwest each spring and fall. It has been estimated that nearly 80% of migrating birds cross through the Platte River Valley in a typical season. Similarly, the Mississippi flyway represents the longest segment from the Arctic coast of Alaska to the Gulf Coast. Generally flat terrain with substantial resources of forests, water, and farmlands, this flyway funnels birds along key waterways such as the Great Lakes and Mississippi River to the interior midwest and southeastern United States and Mexico. Finally, the Atlantic flyway extends from the northern coastal and interior territories of Canada and the eastern Arctic coast, along the Atlantic coast and Allegheny mountain range and into the eastern United States. The termination of this route is Florida and the gateway to the Caribbean.

While the discovery of these migration routes has opened our eyes to the international movement of birds, they also serve as critical information in understanding waterfowl and avian populations and more specifically the human impact on these trends. At the turn of the century, Americans were moving west, growing a Nation and forming farms, roads, and urban cities. The transition of the landscape from undeveloped lands, heavily forested regions, and vast marshes quickly changed to a developing Nation. With such dramatic changes to the environment, Washington along with numerous conservation groups quickly realized the necessity for protection and in many cases were able to divert the loss of some of the most pristine lands within the Union. These included areas such as Yellowstone and others.

One area in particular that escaped this protection was the Great Kankakee Marsh in northwest Indiana. Here, at the southern tip of Lake Michigan and termination of various glacial stages, one half-million acres of marsh supported a huge diversity of aquatic plants including wild rice, fish, waterfowl, quail, Ruffed Grouse, and Prairie Chickens. Ideally located along Lake Michigan, this area was also a staging area for migrating birds transiting Lake Michigan. The area supported an abundance of Sandhill Cranes, Buffalo, Black Bear, Timber wolves, Porcupines, and Trumpeter Swans. In one of the greatest land deals of its time, in the mid-1800's the land was sold for $1.25 an acre. The largest swamp in North America was drained by land speculators to create farms and urban developments. Over the subsequent years, continual flooding made farm development difficult until the Kankakee river was finally dredged.

Sitting on these lands today is an American icon of industrial development, United States Steel. A vast complex of industrial sprawl, U.S. Steel played a critical role in the industrialization and development of America from cars and bridges to railway track. While these actions supported the economic growth of an emerging Nation, unfortunately numerous species that were once common to the area are no longer. Loss of habitat and pollution radically altered the landscape and wildlife irreversibly. Today, only the Sandhill Crane has survived in the region as numerous species once in the area are now gone. Migrating from northern Wisconsin and Minnesota, Sandhill Cranes fly over the remnants of the Great Kankakee Marsh and stage at the Jasper-Pulaski Fish and Wildlife Area in north-central Indiana each fall. Modern day efforts are attempting to restore these lost eco-systems. The formation of the Indiana Dunes National Lakeshore afforded protection to the largest sand dune in Indiana and associated wildlife. Work still continues on restoring portions of the Great Kankakee Marsh and the wildlife it once supported.

This book is organized by examining two parallel themes, the conservation of birds and waterfowl within our National Wildlife Refuges and digital photography techniques used to record these amazing creatures. Only through the achievement of conservation efforts in our preceding years does it make possible the opportunity to record these magnificent moments in the digital medium.

Legislation such as the Clean Air and Water Act, Migratory Bird Treaty Act, and the Endangered Species Act have allowed key species the protection and opportunity to recover. While many factors of economics and biology affect these often politically charged subjects, one fact remains, without the active protection and management of our wildlife resources, we risk significant overpopulation or disastrous extinction. This balance is being played out at wildlife refuges such as Bosque del Apache in New Mexico, J.N. "Ding" Darling in Florida, Sherburne and the Upper Mississippi River in Minnesota. Each area has had considerable challenges and success in fostering the recovery of key species. However, these protected lands also need the benefit of continental cooperation to manage bird counts to safe levels. This can only be achieved through sufficient population studies and assessment of environmental impacts, loss of habitat, hunting and agricultural practices.

As our Nation now starts to see the benefits of a cleaner environment, measurable growth in waterfowl and raptor populations has been observed. At the same time, photography as been turned upside down with the development of the digital SLR camera. This nexus of conservation and digital photography will only continue to bring light to these wonderful species and the benefits of wildlife management. This book attempts to tie these two subjects together for the first time, the power of digital photography and conservation. While we all enjoy reading about the millions of birds that once crossed the sky hundreds of years ago, digital photography has the ability to capture the here and now and propel these issues like never before. In an instant, the events on the refuge can be shared with other bird photographers, wildlife biologists, and conservationists. Issues such as the loss of a bald eagle due to illegal hunting, migration trends, and environmental quality issues can be captured and communicated visually to millions in an instant.

Digital photography technologies are advancing at a phenomenal rate. This book does not focus on the technical specifics of these advancements, rather the techniques used in the field that can be applied to any digital system and to a degree to film cameras as well. While digital SLRs continue to increase in capability and performance, a significant benefit for bird photography today is the 1.3x and 1.5x magnification factors of the imaging CMOS or CCD. This, coupled with a 500mm or 600mm lens has extended the magnification without significant reductions in image quality. Further, the benefits of adjusting ISO settings on the fly is something not possible with conventional film cameras. These factors combined result in higher magnification, faster exposures, and sharper images - ideal for the flight deck.

As conservation efforts continue and further refinements are made in digital photography, it is my hope that photographers and environmentalist alike will continue to join efforts to further the protection of critical species and lands for generations to come. As stewards of the land, we have a responsibility to leverage our creative skills and innovation to further the intentions of our Creator. Like no time before in the history of mankind, we can positively or negatively affect the many wonderful species of birds and waterfowl in the eco-system. These digital rhythms captured herein are only a brief segment in time, reminders of what was. Our responsibility as photographers is to ensure that those who follow us have the same rights and opportunities and that our environment is protected and conserved for generations.

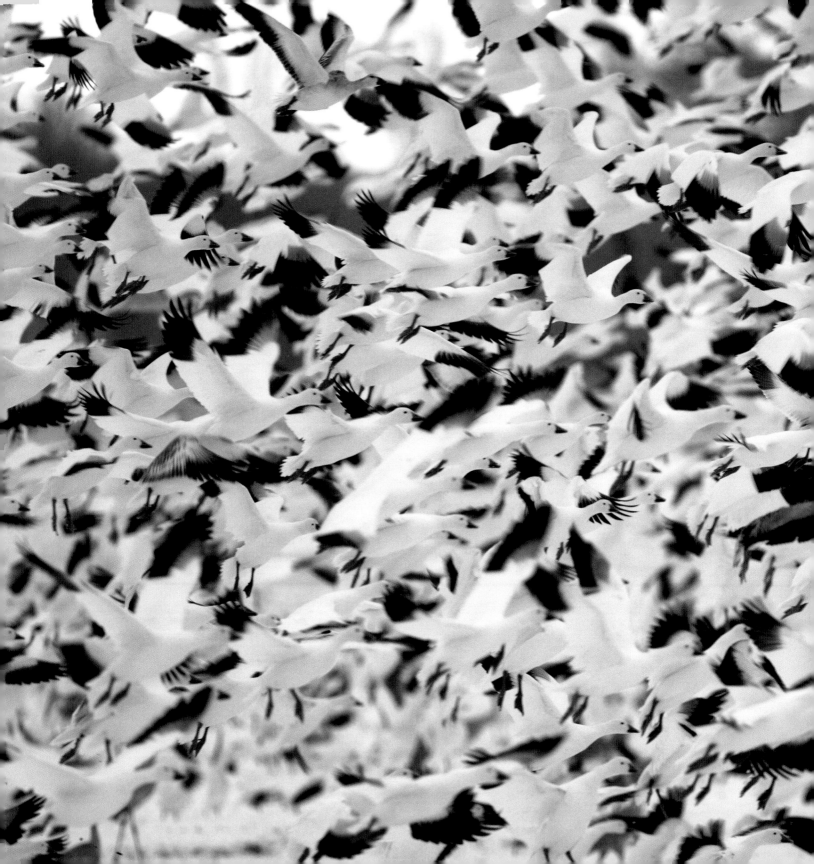

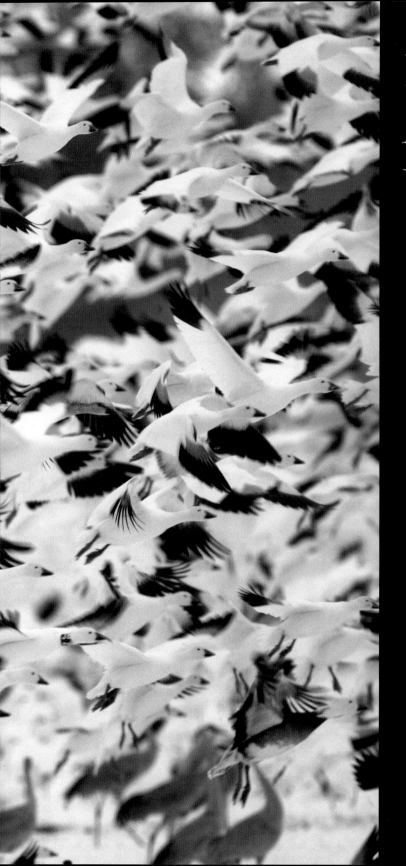

Bosque del Apache National Wildlife Refuge

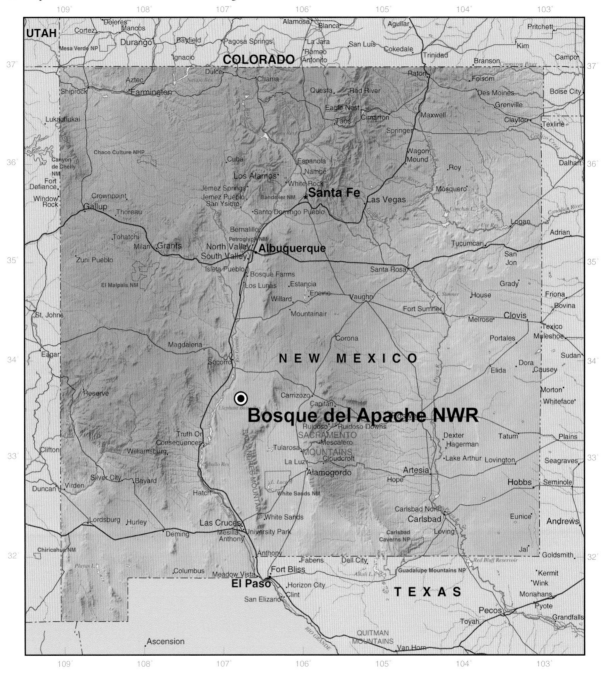

Bosque del Apache NWR

0 100 Miles

0 100 KM

Parallel scale at 34°N 0°E

Migration

Within the Central Flyway, nearly 400,000 Sandhill Cranes form the Rocky Mountain population extending from Colorado and Wyoming to Montana, Idaho, and Utah. During fall migration, these cranes traverse the San Luis Valley in Colorado en route to wintering locations along the Rio Grande in Texas and New Mexico.

In a typical wintering season, a mere 3% or 12,000 of these cranes will converge on the Bosque del Apache National Wildlife Refuge in New Mexico. While managed through hunting and agricultural practices, the population has remained relatively stable over the last ten years.

In the comfort of the refuge, Sandhill Cranes, waterfowl, and raptors find ample water and food sources for the winter. By knocking over the corn stalks (called

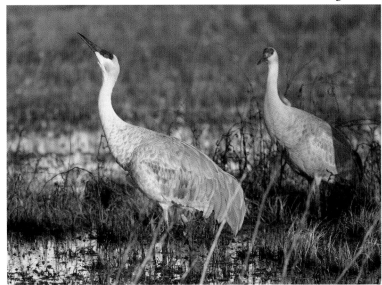

A Sandhill Crane takes a well needed drink. Canon 1d Mark II Camera, 500mm f/4 lens, 1.4x teleconverter (effectively 910mm), ISO 100, 1/100 second at f/5.6.

bumping) on the refuge, cranes can feed freely while geese remain wary of potential predators hidden between the broken stalks. This agricultural practice by the refuge forces geese to distribute and lowers the risk of avian cholera and other diseases from occurring.

During the mid-day, while feeding on the corn and taking a rest,

Snow Geese rest in a bumped cornfield. Canon 1d Mark II Camera, 500mm f/4 lens, 1.4x teleconverter (effectively 910mm), ISO 100, 1/800 second at f/5.6.

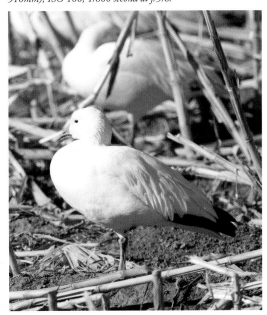

Snow Geese and Sandhill Cranes. Canon 1d Mark II Camera, 500mm f/4 lens, ISO 100, 1/800 second at f/6.3.

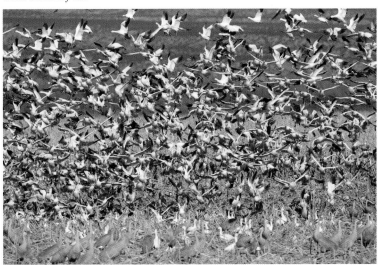

Bosque del Apache National Wildlife Refuge

Snow Geese sporadically take to flight in wildly unpredictable uprisings.

Each season, thousands of cranes, geese, waterfowl, raptors, and other migratory birds con-

A Bald Eagle perches near the Flight Deck. Canon 1d Mark II Camera, 500mm f/4 lens, ISO 400, 1/320 second at f/4.

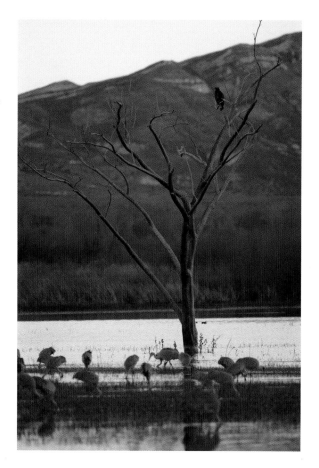

Bald Eagles spar for position. Canon 1d Mark II Camera, 500mm f/4 lens, ISO 100, 1/200 second at f/4.

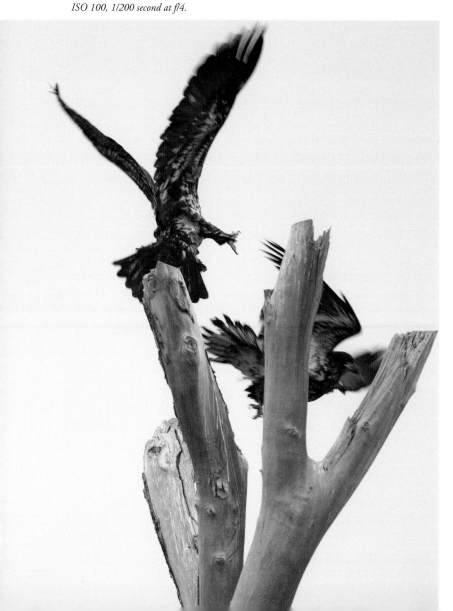

A Great Blue Heron zeroes in on a refuge waterway. Canon 1d Mark II Camera, 500mm f/4 lens, ISO 100, 1/100 second at f/4.

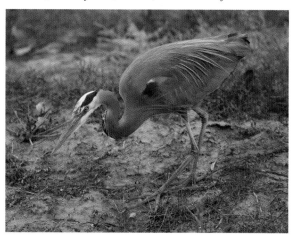

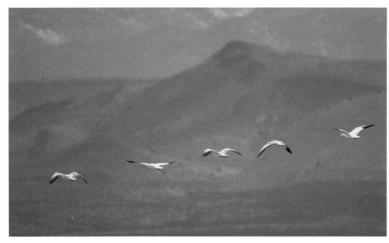

A flock of Snow Geese cruise the refuge. Canon 1d Mark II Camera, 500mm f/4 lens, ISO 100, 1/500 second at f/4.

North American light geese are comprised of the Lesser Snow Goose, Greater Snow Goose, and Ross's goose. These birds have experienced explosive growth rates, tripling since 1970. In 2004, the population exceeded 2.1 million nationally. Nearly one-half resides within the Central Flyway.

Migrating from arctic nesting sites in the Northern Territories of Canada, light geese stage in central Alberta and Saskatchewan. Nearly 30,000 - 60,000 of these birds find their way to the refuge each year. Peak concentrations occur in November and again in February. These large numbers originate from nesting sites in Canada such as Queen Maude Gulf, Anderson River, Howe, Kendall, and Banks Islands. Large numbers have put extreme pressure on Canadian arctic nesting sites, in some cases turning once lush tundra into barren land. With geometric population growth, a number of nesting areas have turned into "eco-systems in peril".

verge on the waters of the Rio Grande and Bosque del Apache National Wildlife Refuge. In a typical season, 20-30 Bald Eagles populate the marsh adjoining the Flight Deck, a visitor observation deck that jets out into the marsh. From the Flight Deck, Bald Eagles are often seen sparing to occupy a dead tree in the center of the marsh.

Digital Equipment
- *Get Stabilized.* Just like with a film camera, it's critical to use a sturdy tripod and mounting head. Winds can be strong on the refuge.
- *Get Comfortable.* Make sure the camera viewfinder is at your eye-level and you can pan left to right rapidly.
- *Panning.* Use a "ball-head" or two-axis mount to track birds in flight. Make sure it functions freely in winter temperatures.
- *Lighten-up.* While it's great to have multiple bodies and lenses, it not only slows you down but can be distracting. Simplify your equipment when shooting.
- *Long lens.* For bird photography under most conditions, a 500mm or longer lens is essential.

Wintering

Snow Goose. Canon 1d Mark II Camera, 500mm f/4 lens, ISO 100, 1/500 second at f/4.

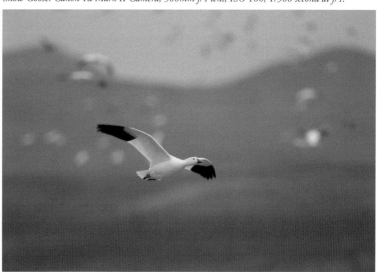

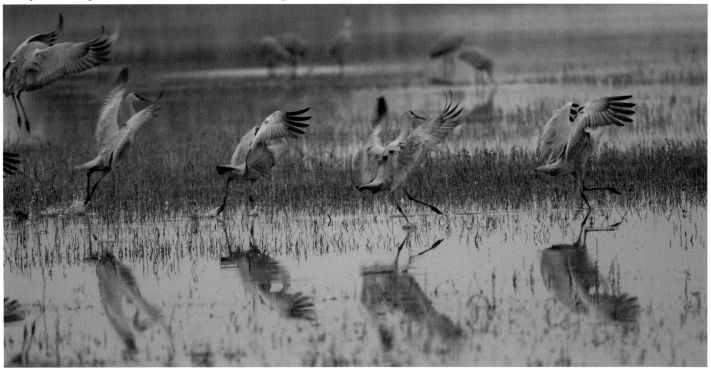

Sandhill Cranes land at the Flight Deck. Canon 1d Mark II Camera, 500mm f/4 lens, ISO 800, 1/320 second at f/4.

Mule Deer. Canon 1d Mark II Camera, 500mm f/4 lens, ISO 1250, 1/30 second at f/4.

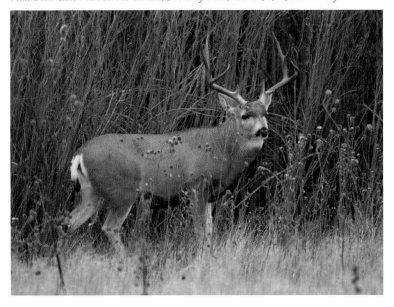

ISO and File Formats

• *ISO on the fly.* Unlike film, digital cameras allow for changing the ISO setting on the fly.

• *Before Increasing ISO.* Eliminate teleconverters, switch to a faster lens, or shoot in brighter conditions. Remember, increasing ISO will increase image noise and reduce overall image quality.

• *Always Shoot RAW.* Your RAW camera setting mode will offer the best bet for image quality and improvements later on the computer.

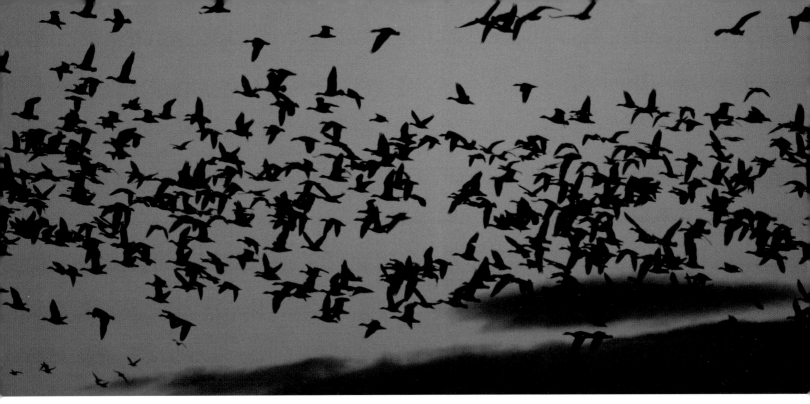

Snow Geese en route to the Flight Deck. Canon 1d Mark II Camera, 500mm f/4 lens, ISO 1250, 1/2000 second at f/4.

Morning Fly-out

Roosting through the night, Sandhill Cranes occupy the marsh waters surrounding the Flight Deck observation platform. In the early morning, before sunrise, thousands of Snow Geese take-off from distant regions all over the refuge and converge on the open waters surrounding the Flight Deck. Massive flocks string across the cold, clear sky in an often chaotic flight path. With thousands in-flight and landing, the black silhouettes of hundreds of Sandhill Cranes remain still, tucked into their overnight positions. As sunrise approaches, Snow Geese go through several sporadic launches and landings.

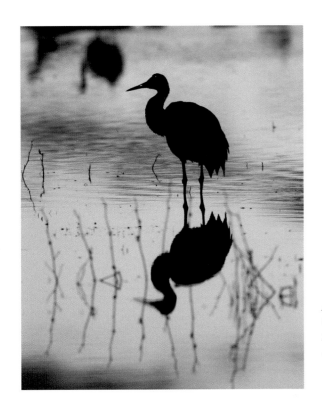

A lone Sandhill Crane. Canon 1d Mark II Camera, 500mm f/4 lens, ISO 1600, 1/200 second at f/4.

Suddenly, in a blink of an eye the entire flock launches again in a loud and amazing roar. This daily pattern is know as the Fly-out.

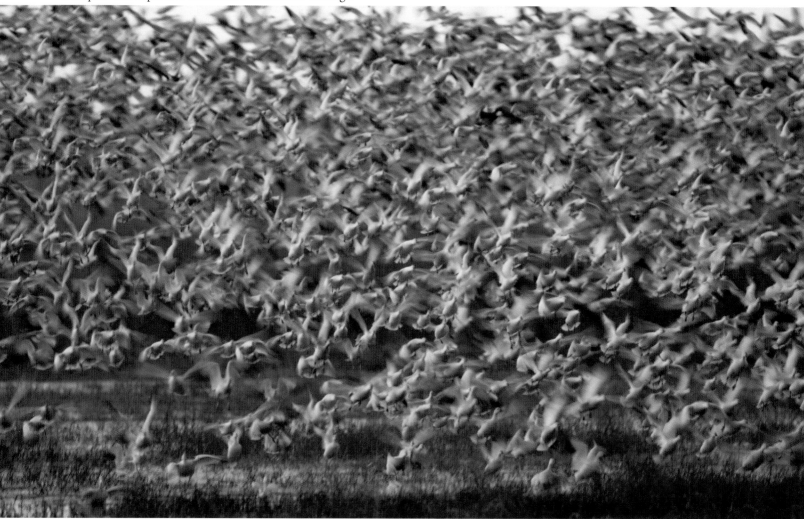

In a sudden eruption, thousands of Snow Geese are airborne. Canon 1d Mark II Camera, 500mm f/4 lens, ISO 1250, 1/50 second at f/4.

The Flock

The extent of the flock on the refuge can be immense in the early morning. Even at 8.5 frames per second, it can be very difficult to determine the motivation for thousands of geese to launch at one time. These daily patterns of movement on the refuge become very predictable during the peak season. Arriving at the Flight Deck in the morning, the flock will usually land just to the southwest in open water.

Surrounded by two roads, thousands of Sandhill Cranes and Snow Geese are greeted each morning by numerous photographers. As the sun breaks the horizon, the flock again bolts into a sudden and unexpected flight, often in two or three major groups. Depending upon the prevailing winds, the departure path is often northwest, directly above the Flight Deck viewing platform.

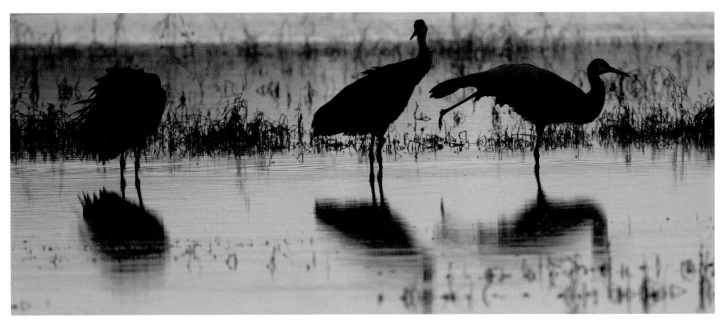

Sandhill Cranes loosen up for the new day. Canon 1d Mark II Camera, 500mm f/4 lens, 1.4x teleconverter (effectively 910mm), ISO 200, 1/320 second at f/5.6.

Relationships

Mating for life, Sandhill Cranes take on a very interactive relationship typically not seen in Snow Geese or other waterfowl. One of the oldest avian species still in existence, they can live up to 30 years. Subtle gestures and audible communications occur regularly. Usually in a small group, one member takes responsibility for surveillance while the others sleep, feed, or stretch. Rarely will all members of a family unit be occupied with the same activity during the day.

As morning comes, the cranes loosen up and prepare for flight, gather family units, and fly-out of the marsh waters to feed in the surrounding farmlands.

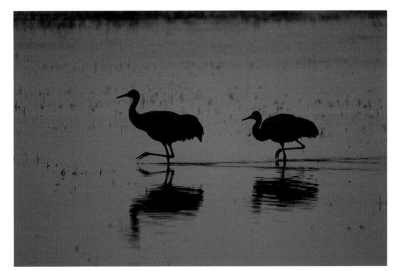

A pair of sandhills silently trace across the marsh. Canon 1d Mark II Camera, 500mm f/4 lens, ISO 400, 1/1000 second at f/4.

Next Page: Snow Geese launch towards the Flight Deck. Canon 1d Mark II Camera, 500mm f/4 lens, ISO 1250, 1/200 second at f/4.

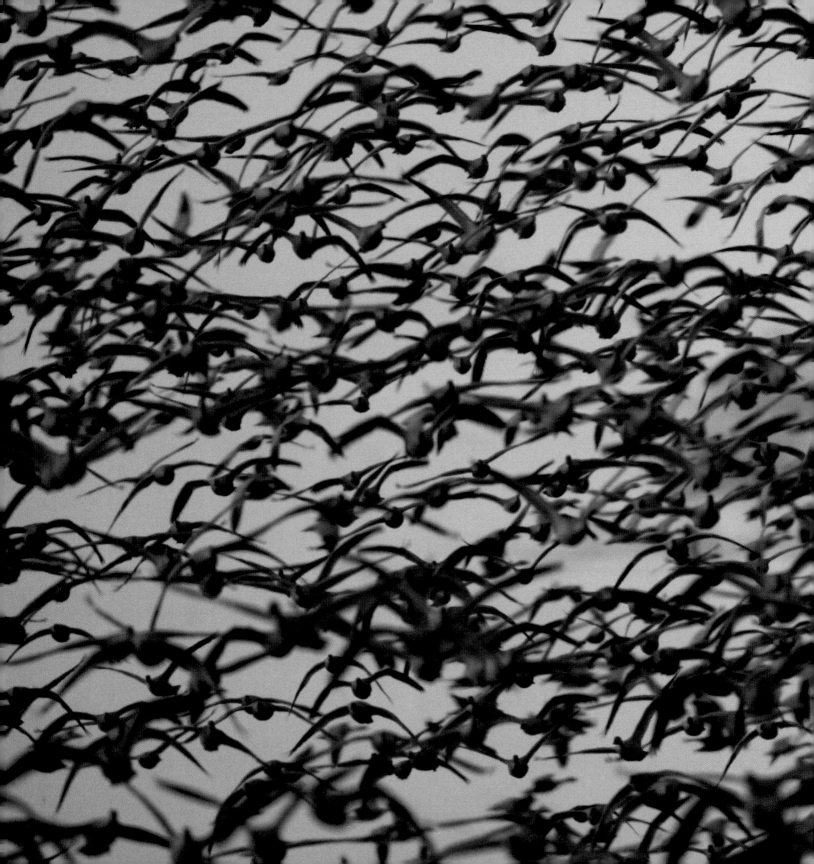

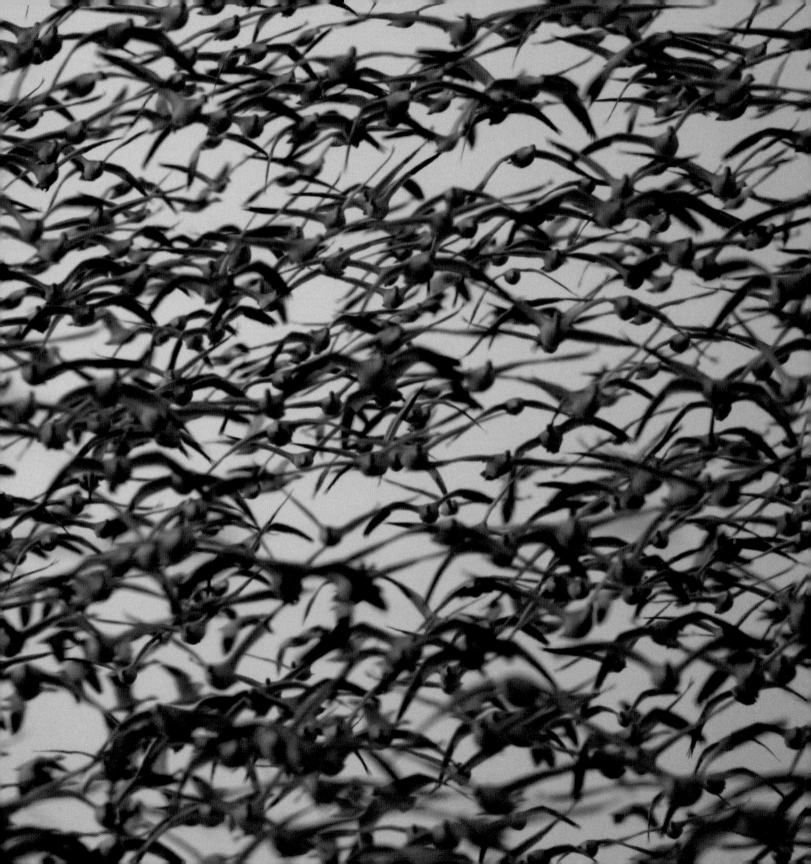

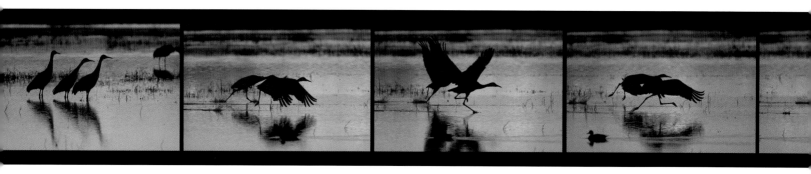

At 8.5 frames per second, two Sandhill Cranes get a running start across the smooth water. Canon 1d Mark II Camera, 500mm f/4 lens, 1.4x teleconverter (effectively 910mm), ISO 200, 1/400 - 1/800 second at f/5.6.

As the sun breaks the horizon in the morning, the smooth waters of the refuge fill with golden light. Minutes later, a pair of Sandhill Cranes signal they are ready for flight. Leaning forward into the direction of departure, they suddenly streak across the surface of the water before

Take-off

A flock of Canadian Geese depart to the southwest from the Flight Deck. Canon 1d Mark II Camera, 500mm f/4 lens, 1.4x teleconverter (effectively 910mm), ISO 200, 1/160 second at f/5.6.

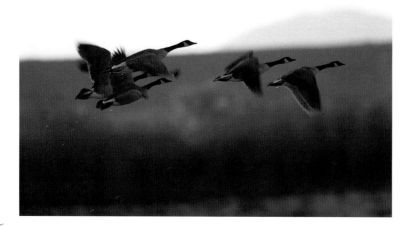

Cold Weather

• *Bring an Extra Battery.* Waiting for sunrise often means exposing your gear to low temperatures and frost, decreasing your battery capacity. Cameras with Li/ion batteries will generally outperform Ni-MH or Ni-CAD. The extra weight and cost of an additional battery is worth it.

• *Turn-off IS.* Turning off your camera lens Image Stabilization will help conserve battery power.

• *Cool down.* Allow sufficient time for your lens and camera body to cool down when shooting in winter environments. Warm equipment when exposed to cold temperatures can give rise to optical distortions and reduced image quality.

• *Arrive Early and Dress Warm.* Prime shooting locations can be filled with other photographers 45 minutes before sunrise.

• *Bring a headlamp.* In the early morning, it's extremely dark on the refuge. Bring an adjustable headlamp with a red light. This keeps both hands available for setup and is easy on the eyes.

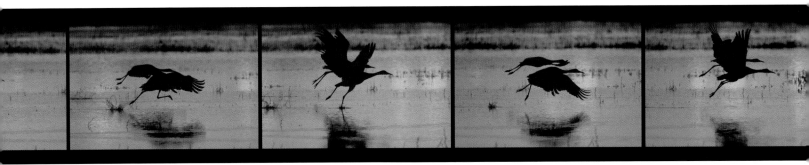

launching into the air. In these situations, the power of digital photography really becomes apparent as high speed frame rates, megapixel resolution, autofocus, and variable ISO settings come together at lightening speeds to capture the fast action flight.

Airborne. Canon 1d Mark II Camera, 500mm f/4 lens, 1.4x teleconverter (effectively 910mm), ISO 200, 1/1250 second at f/5.6.

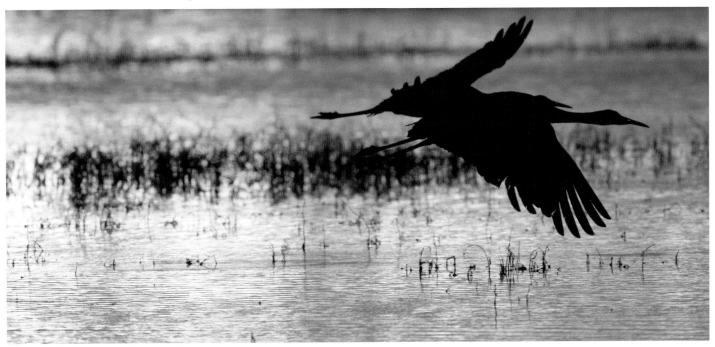

Signaling

Non-verbal communication is a critical tool used by Sandhill Cranes, waterfowl and raptors. Unlike Snow Geese however, Sandhill Cranes exhibit a much more noticeable communication pattern throughout the day that can help unravel impending behavior.

With the sun typically at a 7:30 am position, usually one or two members of a small group lean forward into the wind for several seconds. Suddenly the leader breaks the rigid point and launches into flight. Other members of the group closely follow this lead, occasionally surprised at the departure.

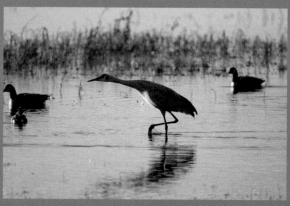

On the verge of take-off. Canon 1d Mark II Camera, 500mm f/4 lens, 1.4x teleconverter (effectively 910mm), ISO 400, 1/1000 second at f/5.6.

Snow Geese patiently wait for the morning fly-out. Canon 1d Mark II Camera, 500mm f/4 lens, 1.4x teleconverter (effectively 910mm), ISO 200, 1/250 second at f/5.6.

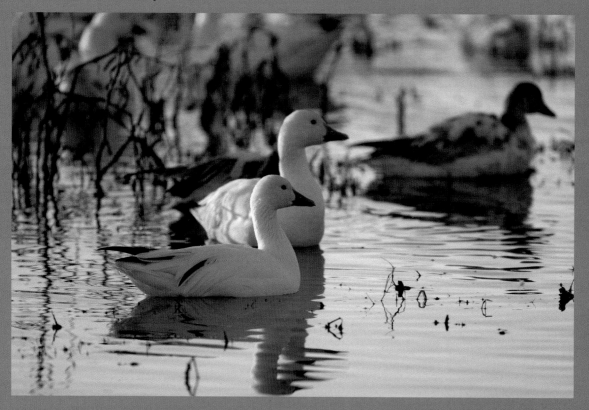

On the ground for no more than thirty minutes in the morning, thousands of Snow Geese take on water and gather at the Flight Deck. In an instant they can erupt into flight.

Suddenly, a group of Sandhill Cranes break into a sprint across the surface of the water. With a couple quick strokes, they are airborne. Canon 1d Mark II Camera, 500mm f/4 lens, 1.4x teleconverter (effectively 910mm), ISO 400, 1/640 second at f/5.6.

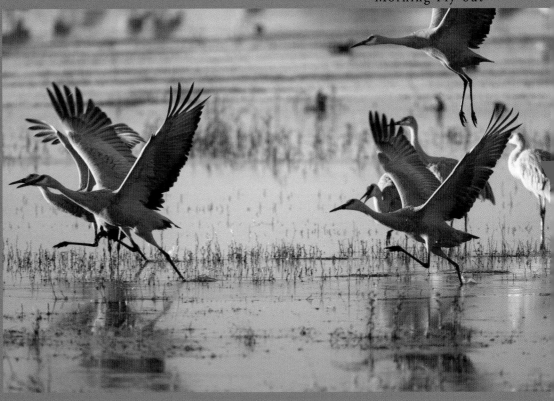

Sandhill Cranes still tucked into their overnight roosting position in the early morning. Canon 1d Mark II Camera, 500mm f/4 lens, 1.4x teleconverter (effectively 910mm), ISO 400, 1/200 second at f/5.6.

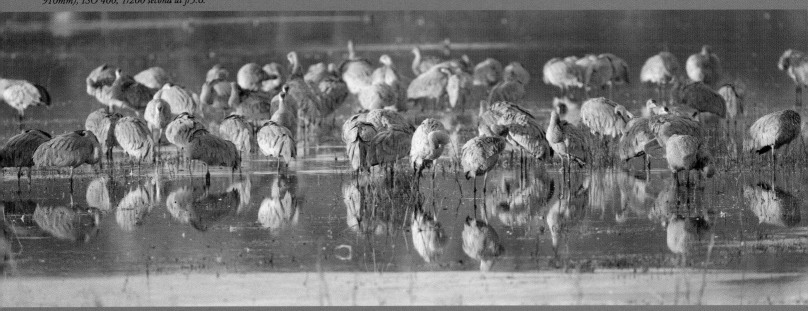

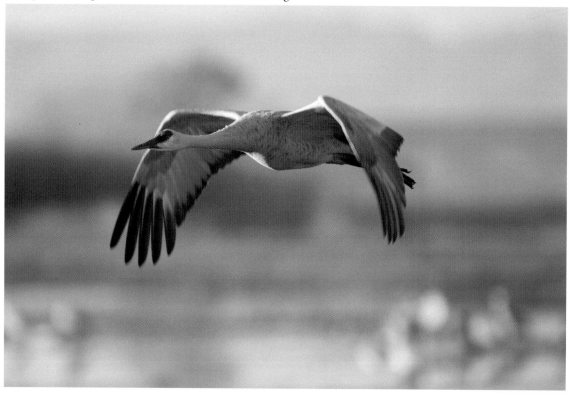

Flying right in front of the Flight Deck, a Sandhill Crane is headed north. Canon 1d Mark II Camera, 500mm f/4 lens, 1.4x teleconverter (effectively 910mm), ISO 400, 1/500 second at f/5.6.

Airborne

Surrounded by hundreds of birds in-flight, and numerous photographers, a Northern Shoveler quietly passes in front of the Flight Deck. Canon 1d Mark II Camera, 500mm f/4 lens, 1.4x teleconverter (effectively 910mm), ISO 200, 1/250 second at f/5.6.

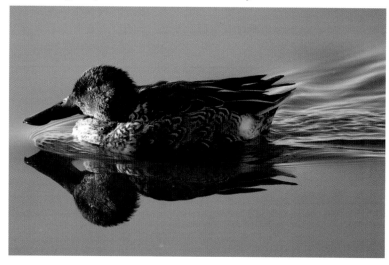

Once airborne, Sandhill Cranes and Snow Geese quickly gain altitude. With daylight building, ISO speeds can be lowered to keep shutter speeds faster than 1/500 of a second, essential for birds in-flight.

Illuminated with a golden glow, Snow Geese and Sandhill Cranes often will fly directly in front of the Flight Deck viewing platform with amazing precision.

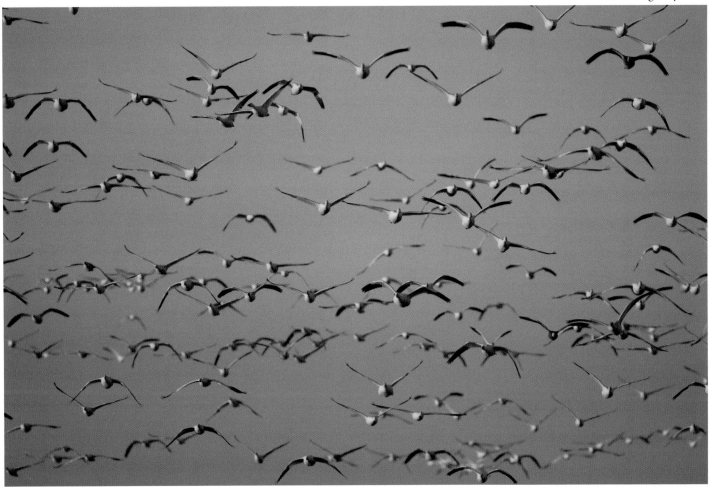

Snow Geese fly-out in early December. Canon 1d Mark II Camera, 500mm f/4 lens, ISO 200, 1/1000 second at f/4.

Conservation

The sheer number of arctic geese on the Bosque del Apache National Wildlife Refuge is simply amazing, awe inspiring, and occasionally worrisome. The colors, sounds, and swarms of flight are humbling. While the refuge has been able to safely support these large numbers, more troubling has been the effect on northern breeding colonies and the subsequent loss of arctic habitat.

Modern agricultural practices of farming corn and other cereal grains on the North American continent continue to provide additional sources of high nutrient foods that have been identified as a leading factor in population growth along with wintering habitats. This uncontrolled growth and spread in wintering ranges forced the U.S. Fish and Wildlife Service in 1999 to revise light goose hunting provisions to increase the yearly harvests. This change combined with observed climatic and other environmental changes have placed the estimated population at 2.1 million in 2004, down from 2.9 million in 1997.

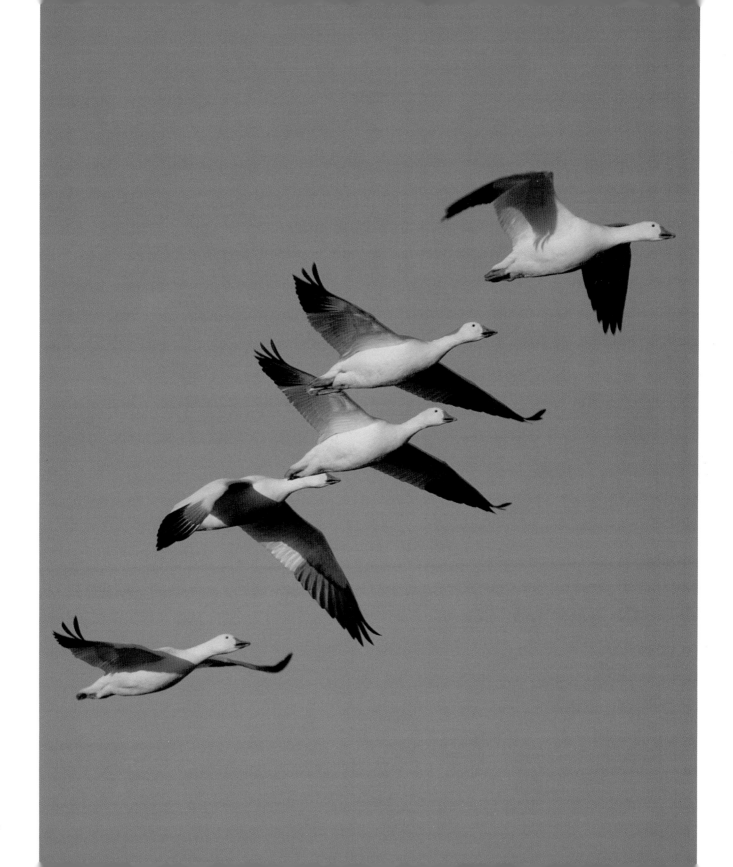

Post Fly-out

Immediately following the fly-out of Snow Geese and Sandhill Cranes from the Flight Deck, the marsh is virtually empty of waterfowl. Lingering throughout the day are Northern Pin-tails, Northern Shovelers, American Coots, and an occasional Bald Eagle. Down the refuge access roads however, coyotes, deer, herons and other wildlife take center stage. As the mid-morning approaches, Snow Geese are much less frequent in-flight while Sandhill Cranes continue to streak across the refuge in flocks of five to ten.

A coyote carefully listens for field mice. Suspecting an early morning breakfast, she launches into the air to get a bird's-eye view of the prey.

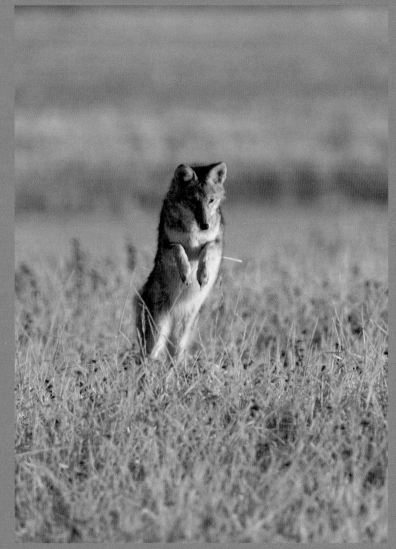

Shooting from the Car

• *Shoot from the Car.* Use a vehicle window mount to shoot from the car. You can cover more ground and have a greater chance of coming up on wildlife rather than waiting for them to come to you.

• *Slow Down.* Often refuge roads are gravel. Driving fast not only spooks wildlife, it generates dust. This dust can filter into your car's ventilation system, camera, and ultimately onto your camera's CCD or CMOS leaving spots on the digital image.

• *Slowly approach a new area.* Carefully study the area. Keep your car window down. When you see a great shot, slowly stop and turn off the engine to reduce vibration and noise.

Coyote. Canon 1d Mark II Camera, 500mm f/4 lens, 1.4x teleconverter (effectively 910mm), ISO 100, 1/500 second at f/5.6.

Snow Geese. Canon 1d Mark II Camera, 500mm f/4 lens, ISO 200, 1/1000 second at f/4.

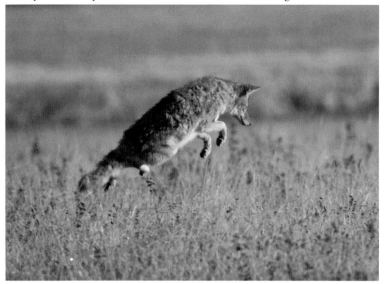

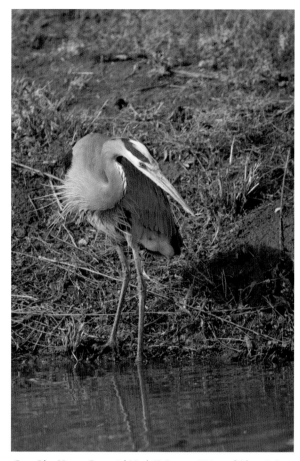

Airborne, the mouse is quickly located. Canon 1d Mark II Camera, 500mm f/4 lens, 1.4x teleconverter (effectively 910mm), ISO 100, 1/500 second at f/5.6.

Jumping high above the marsh grasses, the persistence of the coyote is relentless. Soon, a mid-morning snack is captured. Once eaten, the coyote quickly moves out of view. Meanwhile, a Great Blue Heron locks onto a fish while scanning a marsh drainage way. These irrigation channels are used to control the water levels in the marsh and have the side benefit of supporting numerous herons and aquatic wildlife.

Great Blue Heron. Canon 1d Mark II Camera, 500mm f/4 lens, 1.4x teleconverter (effectively 910mm), ISO 100, 1/500 second at f/5.6.

Canon 1d Mark II Camera, 500mm f/4 lens, 1.4x teleconverter (effectively 910mm), ISO 100, 1/500 second at f/6.3.

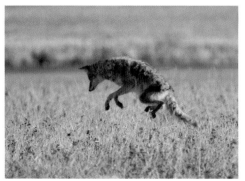

Finally, the coyote takes down a field mouse. Canon 1d Mark II Camera, 500mm f/4 lens, 1.4x teleconverter (effectively 910mm), ISO 100, 1/640 second at f/5.6.

Mid-day Action

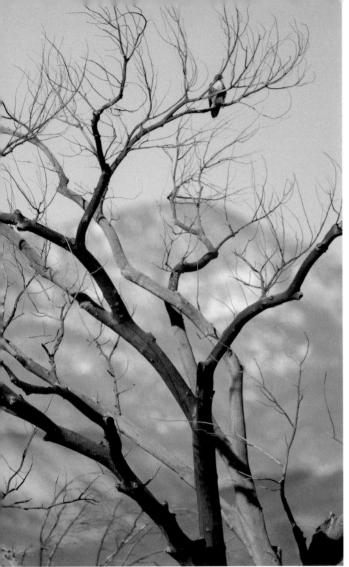

Typical on the refuge, a Red-tailed Hawk watches intently. Canon 1d Mark II Camera, 500mm f/4 lens, 1.4x teleconverter (effectively 910mm), ISO 100, 1/1600 second at f/5.6.

Not to be out-done, a Red-tailed Hawk patiently awaits a turn. Hot on the trail, the hawk launches into flight to chase down a field mouse.

A Red-tailed Hawk launches from a marsh tree. Canon 1d Mark II Camera, 500mm f/4 lens, 1.4x teleconverter (effectively 910mm), ISO 100, 1/640 second at f/5.6.

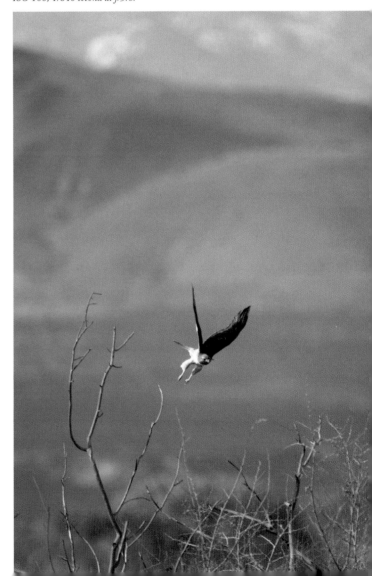

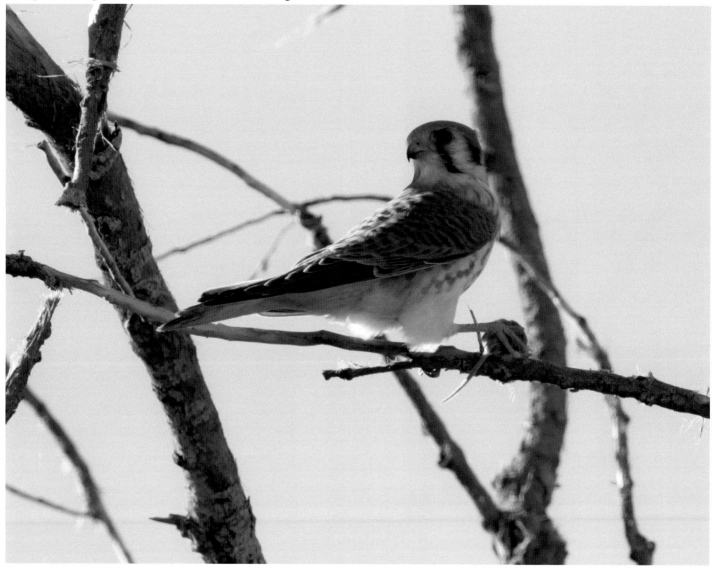

American Kestrel. Canon 1d Mark II Camera, 500mm f/4 lens, 1.4x teleconverter (effectively 910mm), ISO 100, 1/320 second at f/8.

Hunting

Nailed. An American Kestrel has captured a small field mouse and carefully surveys the area for competitors.

During the mid-morning, numerous raptors are seen isolated on the refuge actively searching for prey from strategic viewpoints. Often close to the access roads, they can be easily photographed using the car as a bird blind.

Great Blue Heron. Canon 1d Mark II Camera, 500mm f/4 lens, 1.4x teleconverter (effectively 910mm), ISO 100, 1/800 second at f/5.6.

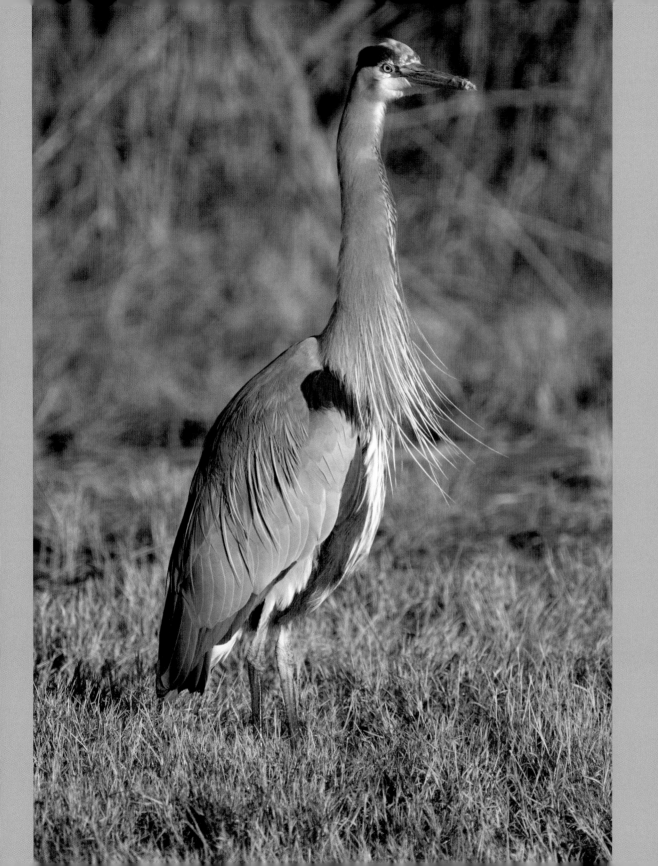

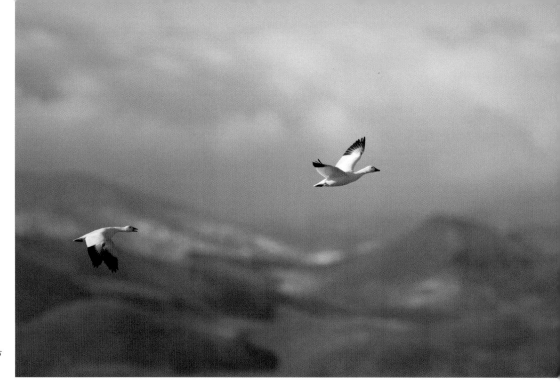

Snow Geese. Canon 1d Mark II Camera, 500mm f/4 lens, ISO 100, 1/1600 second at f/4.

Snow Geese take a mid-day flight with the snow covered Chupadero Mountains in the background.

Bufflehead. Canon 1d Mark II Camera, 500mm f/4 lens, 1.4x teleconverter (effectively 910mm), ISO 100, 1/1000 second at f/5.6.

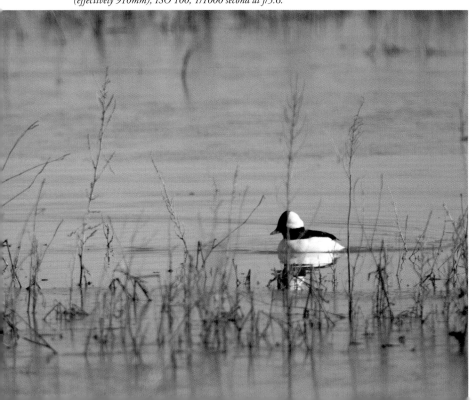

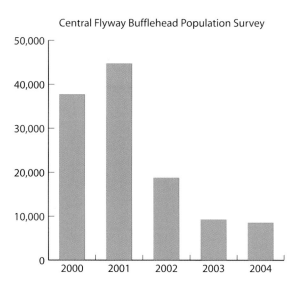

Central Flyway Bufflehead Population Survey

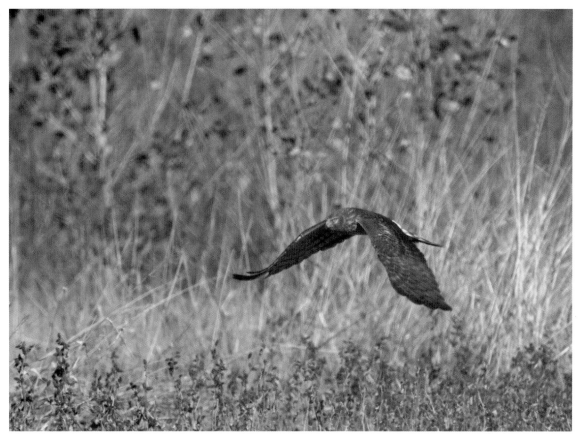

Northern Harrier. Canon 1d Mark II Camera, 500mm f/4 lens, 1.4x teleconverter (effectively 910mm), ISO 100, 1/1250 second at f/5.6.

A Northern Harrier rides low and slow across the edge of the refuge grasslands. Numerous harriers scan the refuge throughout the day.

Populations

As the noon hour approaches, raptors, geese, herons, and cranes spread out into smaller and smaller units. The pace of life slows down as the mid-day heat and bright sun strengthens.

Occasionally, a solitary Bufflehead can be seen on the marsh. Within the Central Flyway, winter population surveys in 2004 estimated the Bufflehead at 8,529 birds. As recently as 2001, the population was closer to 45,000. While some estimates put the entire North American population at 1.4 million, loss of habitat in North America's boreal forest has put pressure on the bird due to logging, agriculture, and development.

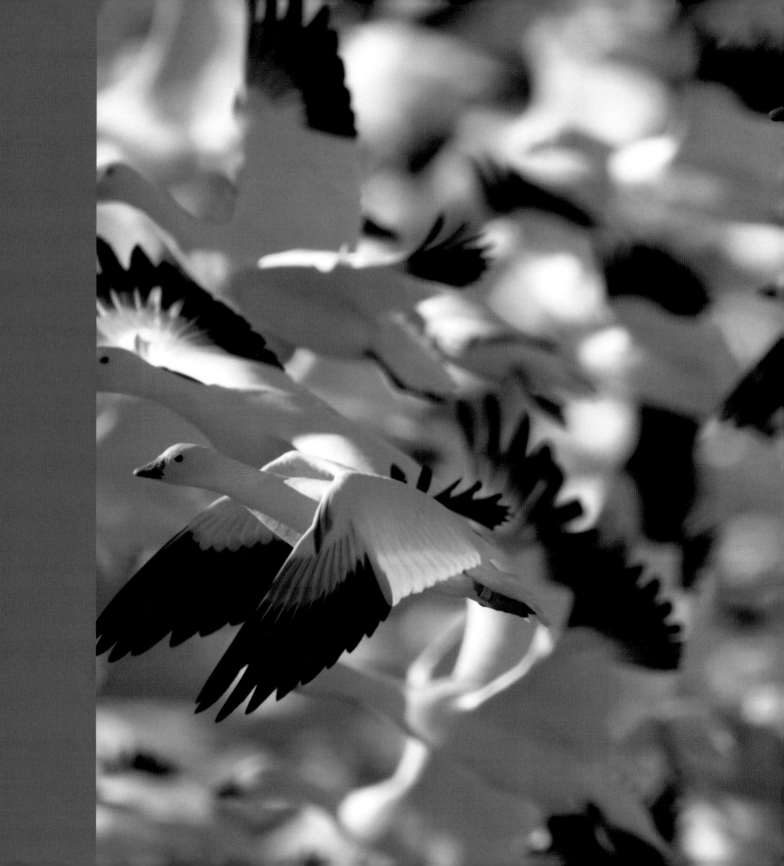

Snow Geese. Canon 1d Mark II Camera, 500mm f/4 lens, 1.4x teleconverter (effectively 910mm), ISO 100, 1/2000 second at f/5.6.

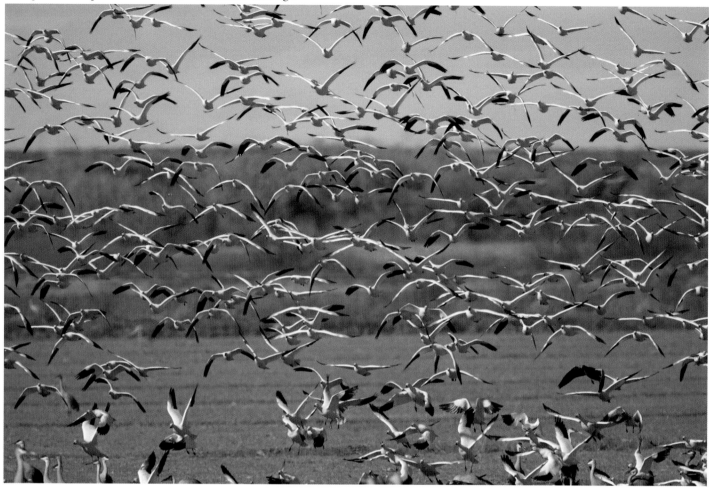

Suddenly the flock erupts into flight. Canon 1d Mark II Camera, 500mm f/4 lens, 1.4x teleconverter (effectively 910mm), ISO 100, 1/1250 second at f/5.6.

Farmlands and Marshes

Feeding and roosting habitats are critical factors in Snow Geese and crane populations. During mid-day on the refuge, Snow Geese assemble in cut and bumped fields. Timely manipulations of agricultural crops have proven to be an effective way of managing bird distributions not only on the refuge, but on public lands as well. Corn, winter wheat, and alfalfa play a critical role in influencing light geese movements and migration patterns. Cranes and geese will also feed on naturally occurring moist soil food plants. In the winter, these birds shift to these sources as a critical source of nutrients necessary for molting. At the marsh, activity slows with an occasional Red-tailed Hawk or Bald Eagle occupying a lone tree for hours.

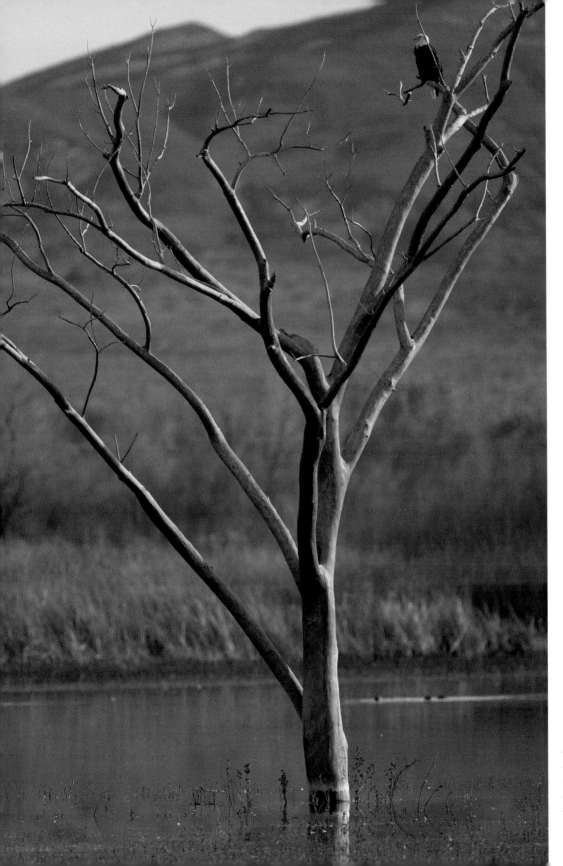

*Bald Eagle. Canon 1d Mark
II Camera, 500mm f/4 lens,
1.4x teleconverter (effectively
910mm), ISO 100, 1/500
second at f/5.6.*

43

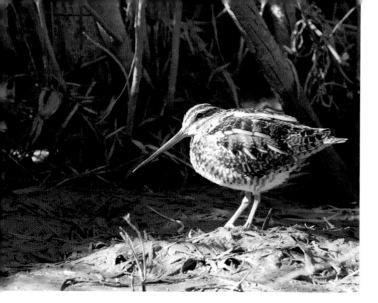

A rare sight on the refuge, a Common Snipe lays low in the marsh mud. Canon 1d Mark II Camera, 500mm f/4 lens, 1.4x teleconverter (effectively 910mm), ISO 100, 1/100 second at f/5.6.

Smaller Birds

While cranes and geese continually sweep across the refuge in the mid-day sun, a wide range of shorebirds, warblers, and Roadrunners perch near the roadside. A common sight on the refuge, Roadrunners periodically freeze in their path with an eerie eye towards predators and prey.

An American Kestrel perches high over a refuge access road. Canon 1d Mark II Camera, 500mm f/4 lens, 1.4x teleconverter (effectively 910mm), ISO 100, 1/1000 second at f/5.6.

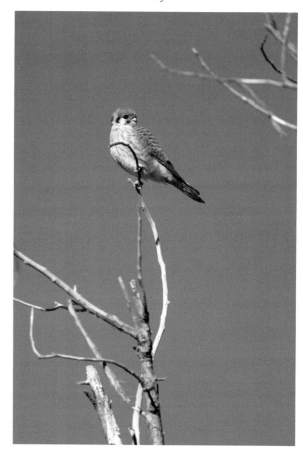

A solitary Say's Phoebe rides the swaying branches of a roadside tree. Canon 1d Mark II Camera, 500mm f/4 lens, 1.4x teleconverter (effectively 910mm), ISO 100, 1/1000 second at f/5.6.

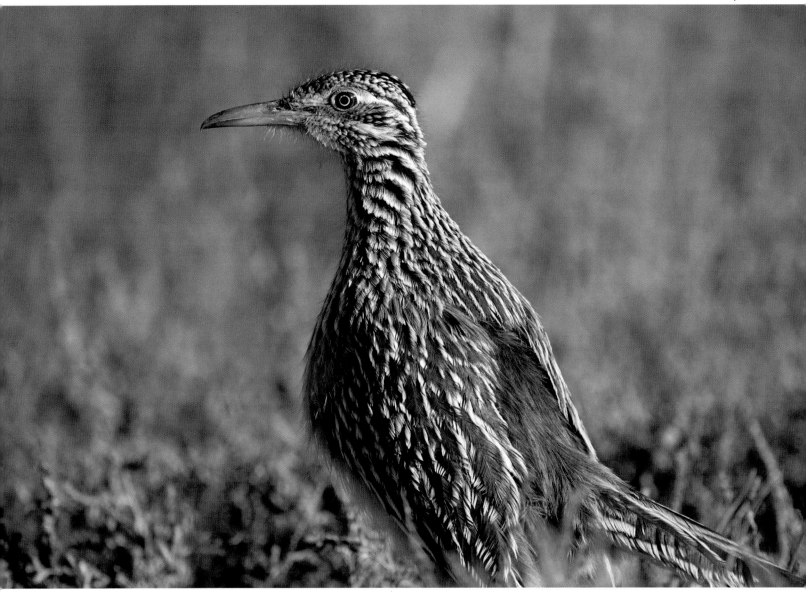

Roadrunner. Canon 1d Mark II Camera, 500mm f/4 lens, ISO 100, 1/1000 second at f/4.

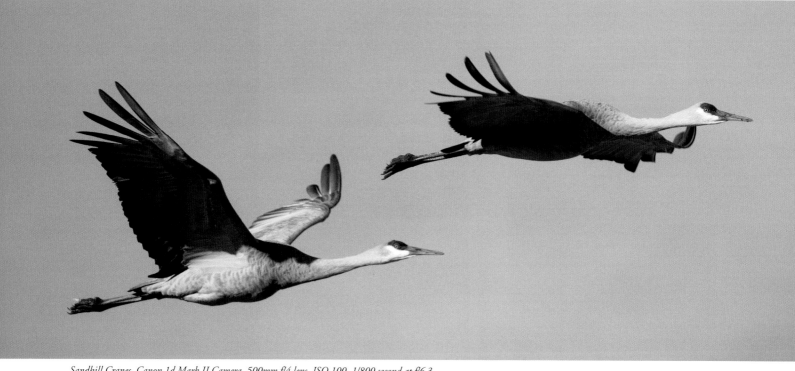

Sandhill Cranes. Canon 1d Mark II Camera, 500mm f/4 lens, ISO 100, 1/800 second at f/6.3.

With strong mid-day sun, shutter speeds can increase significantly for sharp, stop action photography. Here, a male and female pair of Sandhill Cranes rides silently across a cornfield on the refuge. Meanwhile, not far away a lone Hooded Merganser quietly floats on a nearby pond. During the 2004 winter population survey, it was estimated that 4,177 Hooded Mergansers wintered in New Mexico, only 6% of the total population within the Central Flyway. Within the Central Flyway, in the last four years, this bird has seen a 35% reduction in its population.

Birds in Flight

• *Close down that Aperture.* Closing the aperture one or two stops from maximum will increase sharpness of birds in-flight. Use maximum aperture settings for reduced light conditions to maintain shutter speeds above 1/500 for birds in flight.

• *Maximize Frame Rate.* Shooting fast moving birds requires quick autofocus and frames per second (fps). Both are critically important. Target 8 fps or better for a digital SLR body.

Hooded Merganser. Canon 1d Mark II Camera, 500mm f/4 lens, 1.4x teleconverter (effectively 910mm), ISO 100, 1/320 second at f/8.

For Life

Sandhill Cranes form strong family ties and are typically observed in pairs or larger groupings. Although sandhills are protected in many states, they are legally hunted in twelve and in Canada and Mexico. In 2003, nearly 19,000 cranes were harvested through legal hunting, with 63% of the harvest being taken in Texas. While adults can live long lives, young cranes are much more susceptible to predators such as crows, ravens, skunks, raccoons, coyotes and inadvertent flight into fences and power lines.

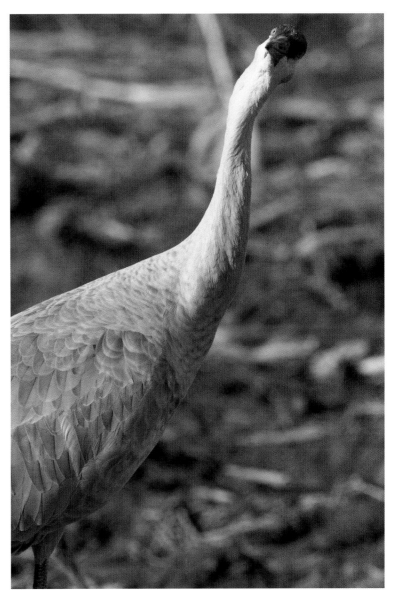

Sandhill Crane. Canon 1d Mark II Camera, 500mm f/4 lens, ISO 400, 1/800 second at f/11.

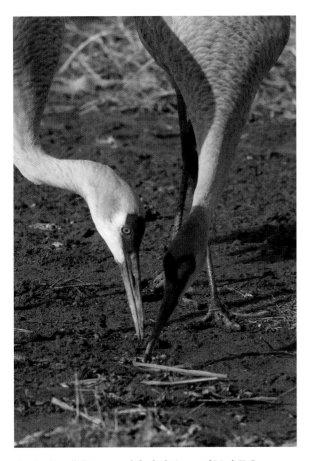

A pair of Sandhill Cranes grub for food. Canon 1d Mark II Camera, 500mm f/4 lens, ISO 400, 1/800 second at f/11.

Afternoon Break

As the sun starts to sag in the afternoon sky, thousands of Snow Geese fill a bumped farm field on the refuge. While some rest, many others keep a vigilant eye. During this time of day, the flock is flushed much less frequently than in the early morning and is generally quieter.

This is a common sight as Snow Geese often seek out corn, wheat, barley, oat, rye and other agricultural crops in the winter. This reliance on winter crops continues to drive population counts higher. Since 1969, the mid-continent population of light geese has risen from 700,000 to over 2.1 million in 2004. Peaking near three million in 1998, growth rates have receded as a result of changes in regulated hunting and the availability of habitat and crops.

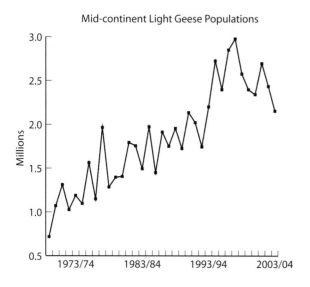

Mid-continent Light Geese Populations

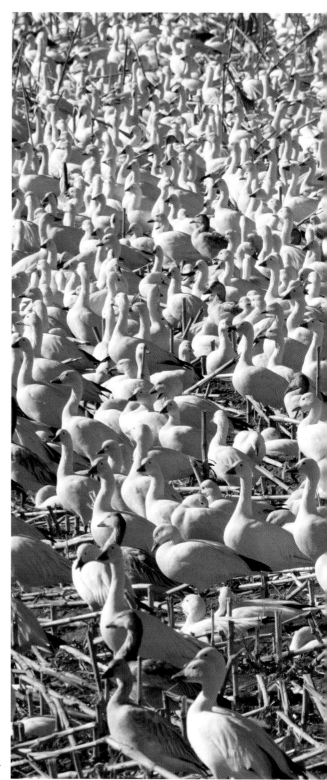

Snow Geese. Canon 1d Mark II Camera, 500mm f/4 lens, ISO 100, 1/60 second at f/22.

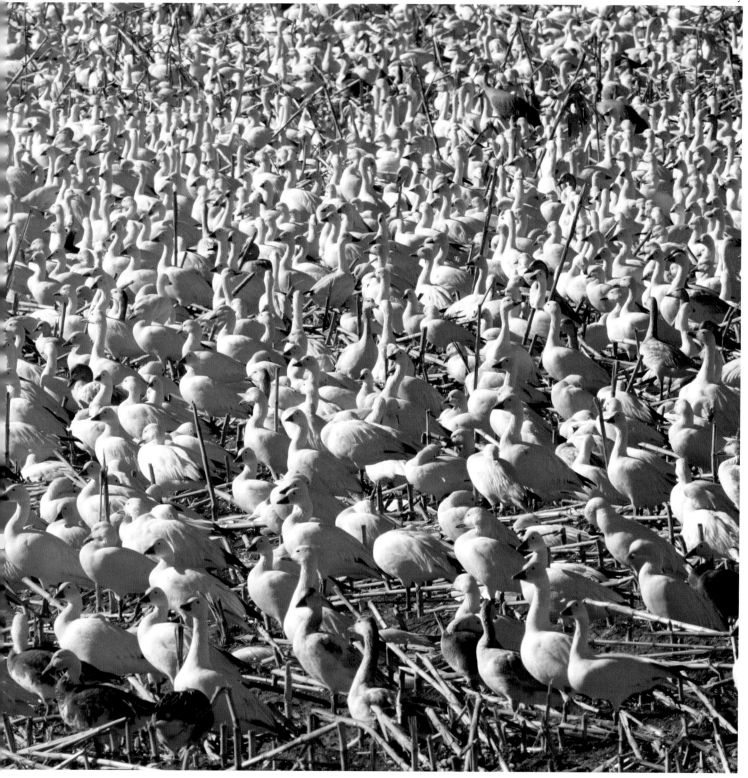

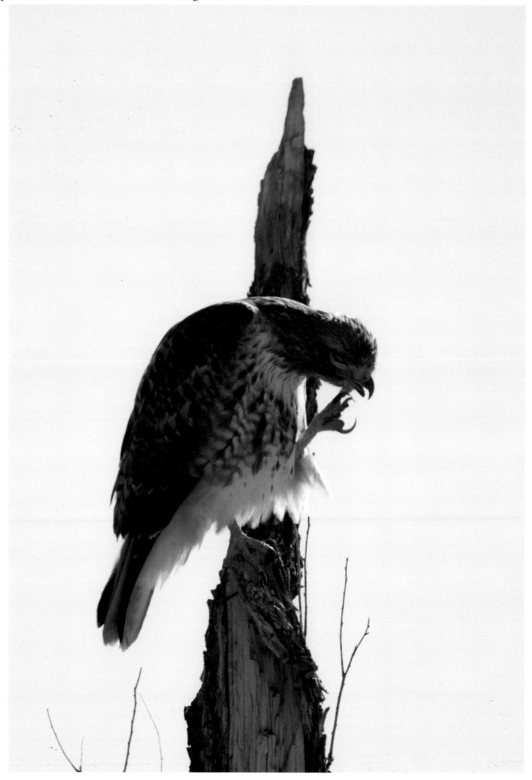

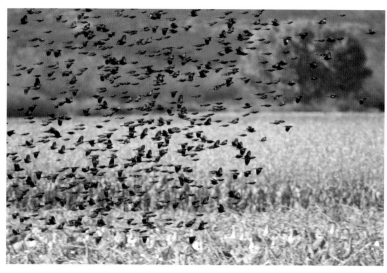

*Red-winged Blackbirds. Canon
1d Mark II Camera, 500mm
f/4 lens, 1.4x teleconverter
(effectively 910mm), ISO 100,
1/400 second at f/5.6.*

*Not to be outdone, a flock of Red-winged
Blackbirds launch into flight.*

*A Sharp-shinned Hawk carefully observes the marsh from the treeline. Canon 1d Mark II
Camera, 500mm f/4 lens, 1.4x teleconverter (effectively 910mm), ISO 800, 1/250 second at
f/7.1.*

*Red-tailed Hawk. Canon 1d Mark II Camera, 500mm f/4 lens, 1.4x
teleconverter (effectively 910mm), ISO 100, 1/640 second at f/5.6.*

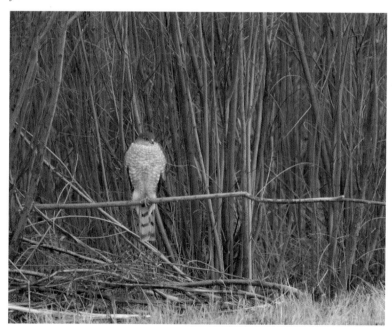

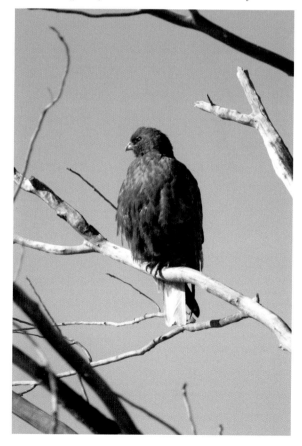

*Red-tailed Hawk. Canon 1d Mark II Camera, 500mm f/4
lens, 1.4x teleconverter (effectively 910mm), ISO 100, 1/500
second at f/5.6.*

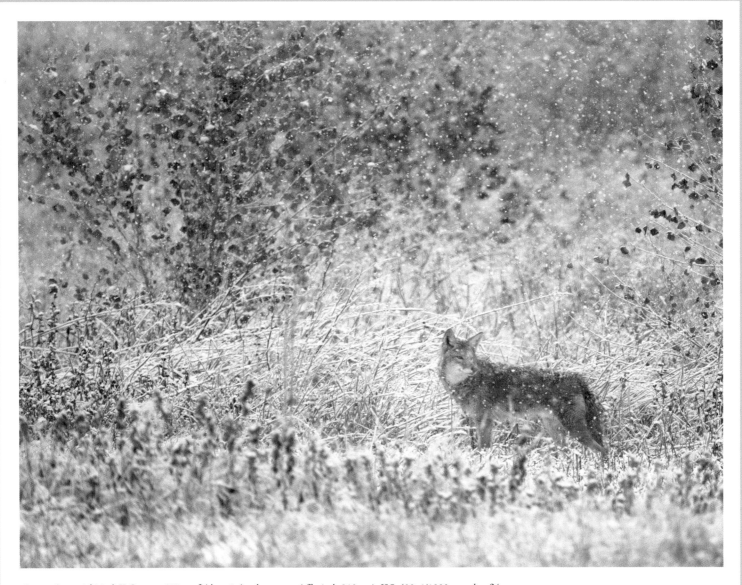

Coyote. Canon 1d Mark II Camera, 500mm f/4 lens, 1.4x teleconverter (effectively 910mm), ISO 400, 1/1000 second at f/4.

Winter Storms

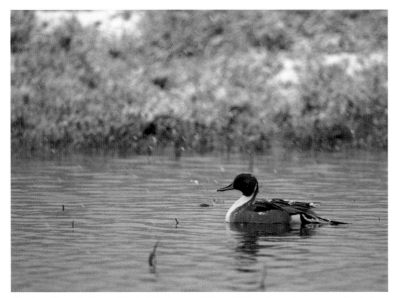

In early December, winter storms can come up quickly and blanket the refuge with a fresh layer of heavy, wet snow. Roads can become impassible. Soon, flight operations slow as pin-tails, deer, and coyotes have reduced visibility.

Northern Pin-tail. Canon 1d Mark II Camera, 500mm f/4 lens, 1.4x teleconverter (effectively 910mm), ISO 400, 1/160 second at f/4.

Mule Deer. Canon 1d Mark II Camera, 500mm f/4 lens, 1.4x teleconverter (effectively 910mm), ISO 400, 1/400 second at f/5.6.

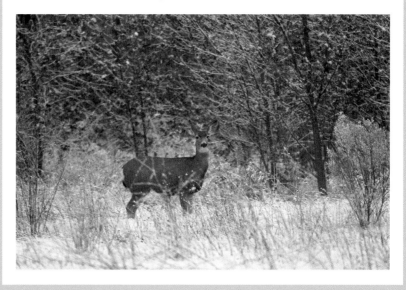

Winter Weather

• *Stay Dry.* Shooting in heavy, wet snow, it's important to shield your equipment from the elements. Use a protective nylon lens cover to minimize moisture and dress appropriately to endure the weather conditions.

• *Sun Shade.* Always use your camera's sunshade. This device reduces flare, increases contrast, and reduces water and particles from collecting on the outer lens surface.

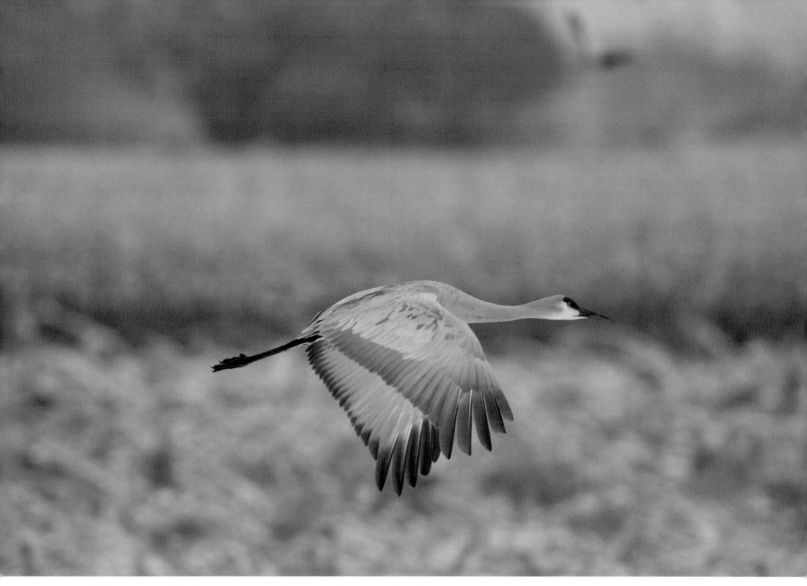

Sandhill Crane. Canon 1d Mark II Camera, 500mm f/4 lens, 1.4x teleconverter (effectively 910mm), ISO 400, 1/500 second at f/6.3.

Grounded

With light winds and heavy, wet snow falling a sandhill attempts a take-off. For the majority of the flock and associated geese, most stay on the ground to wait out the weather. Freezing cold, Snow Geese blend into the new blanket of snow on the cornfield. Opening up 1 1/2 - 2 stops, the geese and snow can be exposed properly.

A Krider's Red-tailed Hawk overlooks the snow covered farm to the north. Canon 1d Mark II Camera, 500mm f/4 lens, 1.4x teleconverter (effectively 910mm), ISO 400, 1/800 second at f/5.6.

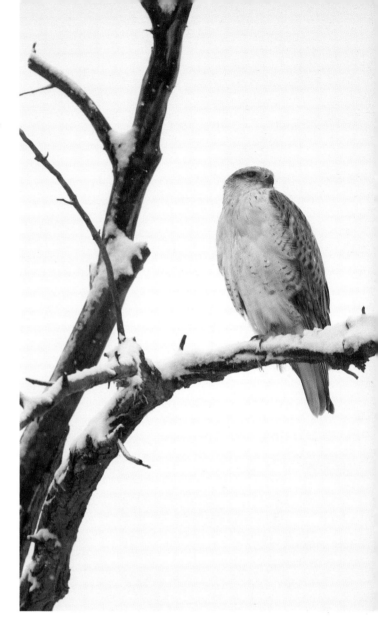

Snow Geese blend into remnants of a winter storm. Canon 1d Mark II Camera, 500mm f/4 lens, 1.4x teleconverter (effectively 910mm), ISO 400, 1/125 second at f/11.

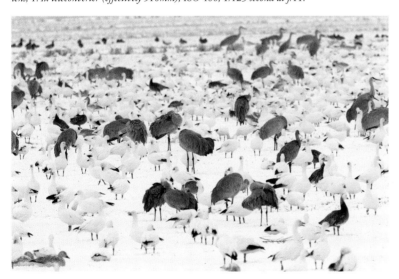

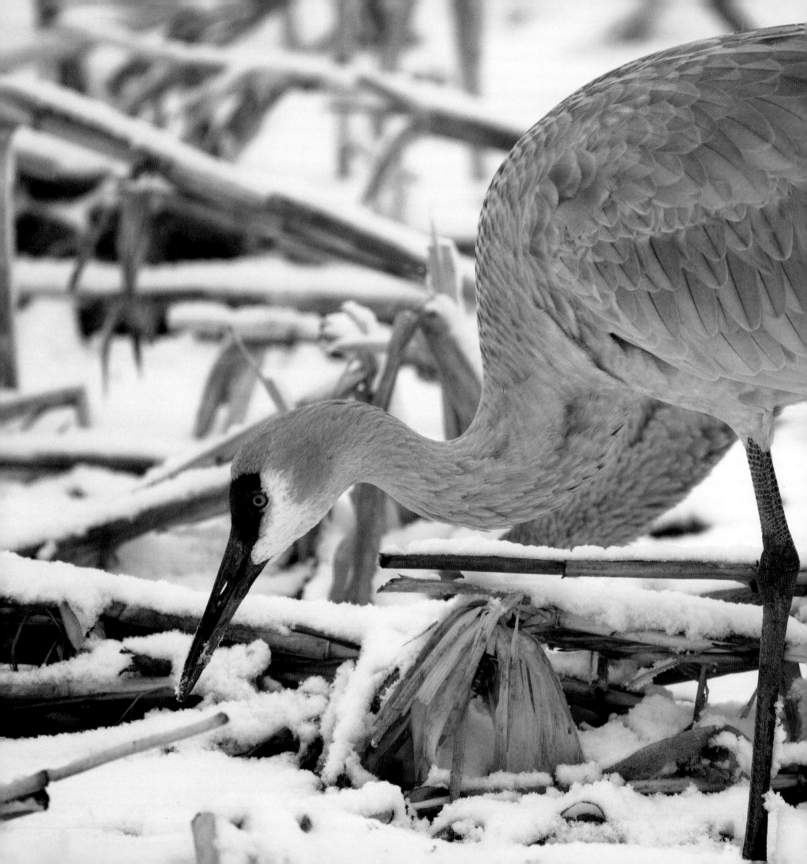

A pair of Sandhill Cranes push through the snow to find food.

Canon 1d Mark II Camera, 500mm f/4 lens, 1.4x teleconverter (effectively 910mm), ISO 400, 1/320 second at f/5.6.

Evening Fly-in

Sandhill Cranes swarm on the marsh surrounding the Flight Deck. Canon 1d Mark II Camera, 500mm f/4 lens, 1.4x teleconverter (effectively 910mm), ISO 100, 1/640 second at f/5.6.

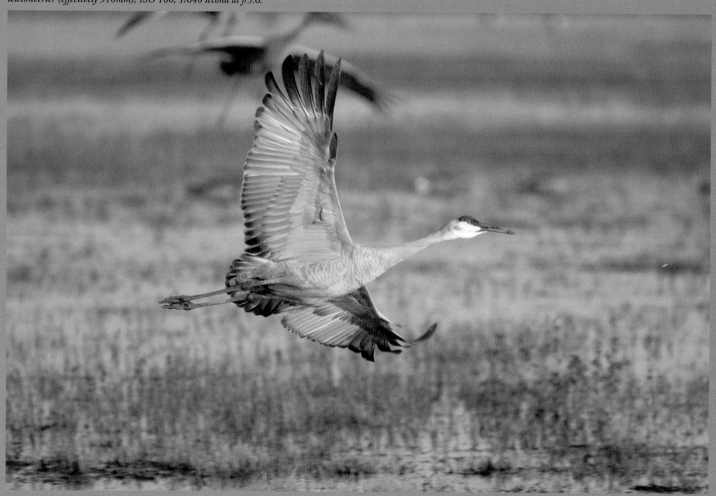

Just as fast as the snow appeared, six inches of snow can quickly melt by late afternoon. With temperatures warming and the sun setting, sandhills start making their way back to the marsh waters surrounding the Flight Deck viewing platform, where their day first started, for the evening Fly-in.

First in pairs and then larger units of six or seven, sandhills approach in wave after wave for two hours leading up to sunset. Flapping their enormous wings, they quickly slow and drop vertically into the water.

Birds in Flight
• *Get Close.* When lighting conditions are present, use a 1.4x teleconverter to increase the effective magnification of your lens.
• *Maintain a Fast Shutter.* As the light decreases, increase aperture, drop the teleconverter, and then increase ISO to ensure the best image quality during sunset.

A Sandhill Crane lands at the Flight Deck. Canon 1d Mark II Camera, 500mm f/4 lens, 1.4x teleconverter (effectively 910mm), ISO 100, 1/500 second at f/5.6.

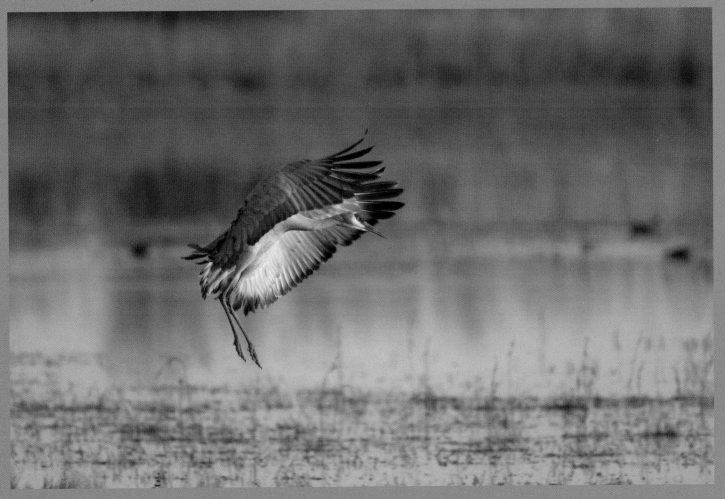

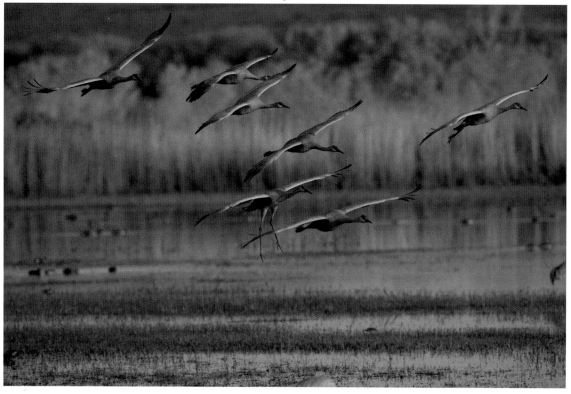

Sandhill Cranes on approach. Canon 1d Mark II Camera, 500mm f/4 lens, ISO 200, 1/800 second at f/5.6.

The Flight Deck

The quantity of sandhills approaching quickly becomes overwhelming. As if an alarm went off, hundreds are en route from distant regions of the refuge converging on the Flight Deck. Sometimes announcing with a prehistoric honk, other times in pure silence, the marsh quickly fills with cranes.

Immediately upon landing, sandhills will take a well-needed drink and slowly raise their bills skyward to swallow the water.

A Sandhill Crane arrives at the Flight Deck. Canon 1d Mark II Camera, 500mm f/4 lens, 1.4x teleconverter (effectively 910mm), ISO 100, 1/640 second at f/5.6.

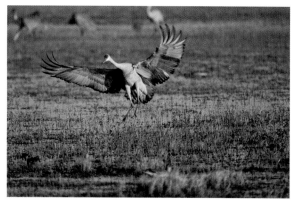

Canon 1d Mark II Camera, 500mm f/4 lens, ISO 200, 1/800 second at f/4.

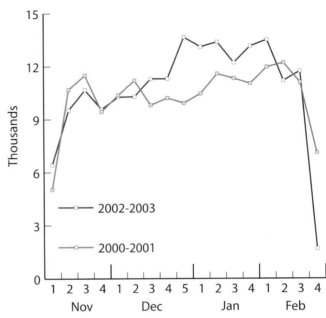

Bosque del Apache National Wildlife Refuge
Weekly Wintering Sandhill Crane Populations

Starting in November each year, Sandhill Crane populations slowly increase, peaking in mid-January. By mid-February, the population rapidly drops off as cranes depart the refuge and return north.

Weighted down with mud from the melting snow, this sandhill announces an arrival.
Canon 1d Mark II Camera, 500mm f/4 lens, ISO 200, 1/500 second at f/5.6.

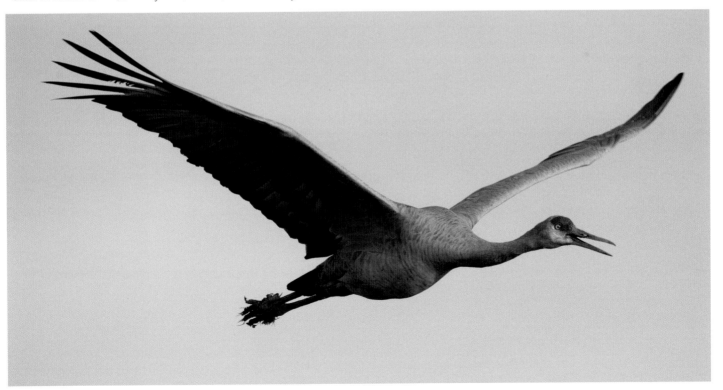

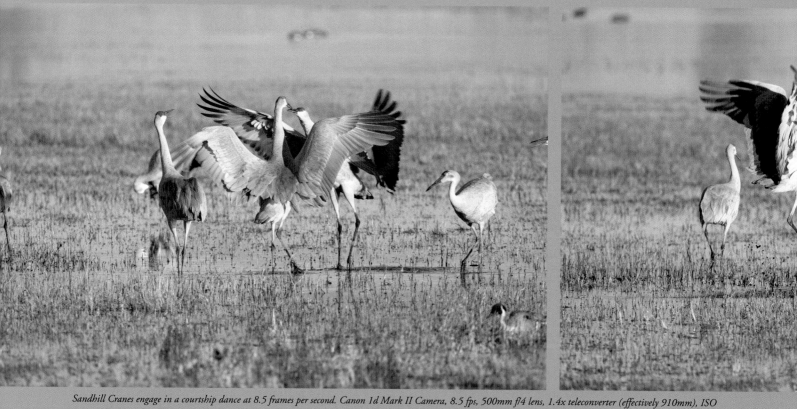

Sandhill Cranes engage in a courtship dance at 8.5 frames per second. Canon 1d Mark II Camera, 8.5 fps, 500mm f/4 lens, 1.4x teleconverter (effectively 910mm), ISO 100, 1/400 second at f/7.1.

Courtship Dancing

Digital Equipment

• *Frames Per Second (fps).* At 8.5 fps, suddenly a whole new world opens up. Unlike film, digital photography allows for a large number of images to be taken and only the best retained.

• *Resist the Temptation.* Resist the temptation to excessively view and judge images as they are taken. While you are looking at your display, you can be missing a great shot.

Soon after landing, sandhills continue to seek out a partner with a tremendous courtship dance. Jumping three or four feet into the air, extending their wingspan, and carrying on an audible interchange, sandhills attempt to establish dominance and win the favor of a mate.

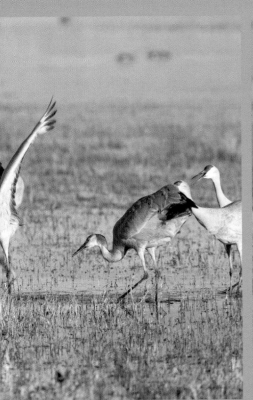

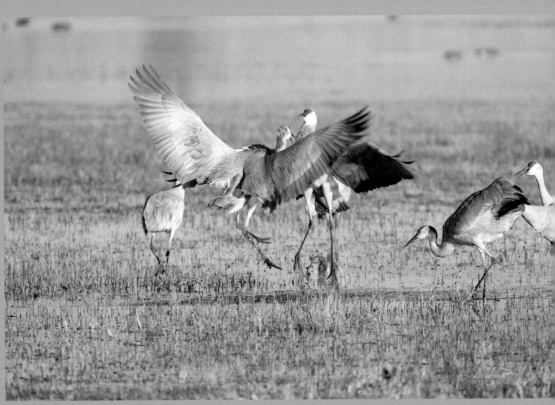

Canon 1d Mark II Camera, 500mm f/4 lens, 1.4x teleconverter (effectively 910mm) ISO 100, 1/500 second at f/5.6.

Meanwhile as several sandhills make a commotion on the refuge, three cranes stealthily stream in front of the Flight Deck.

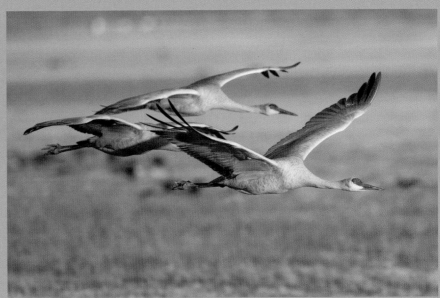

Bosque del Apache National Wildlife Refuge

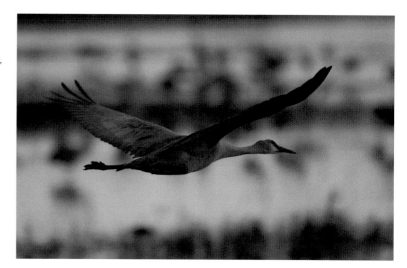

*Canon 1d Mark II Camera,
500mm f/4 lens, ISO 800,
1/500 second at f/4.*

*As daylight quickly recedes,
sandhills continue to swarm on
the marsh. Some isolated, others
in smaller groups.*

Canon 1d Mark II Camera, 500mm f/4 lens, 1.4x teleconverter (effectively 910mm) ISO 100, 1/400 second
at f/5.6.

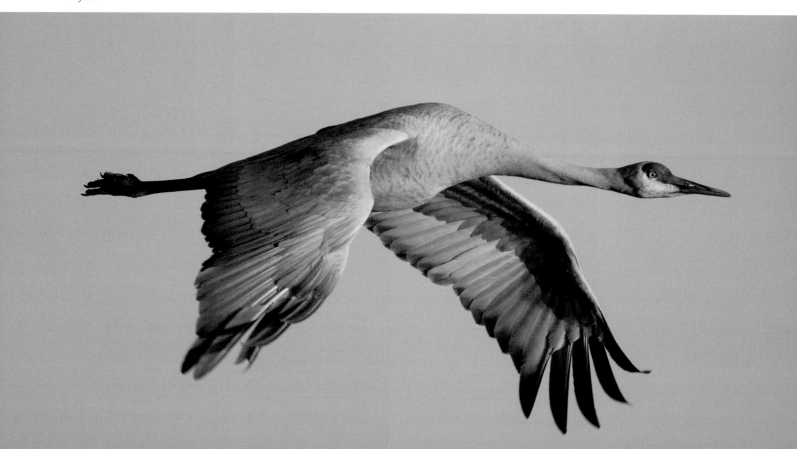

Canon 1d Mark II Camera,
500mm f/4 lens, ISO 800,
1/1000 second at f/4.

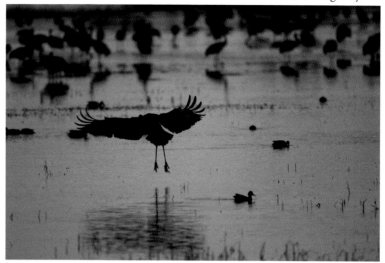

*As the sun slips under the horizon,
sandhills and other waterfowl turn to silhouettes
just as in the morning. Backlight with a colorful
New Mexico sunset, the refuge starts to quiet
down for the night.*

Sunset

Canon 1d Mark II Camera, 500mm f/4 lens, 1.4x teleconverter (effectively 910mm) ISO 100,
1/125 second at f/5.6.

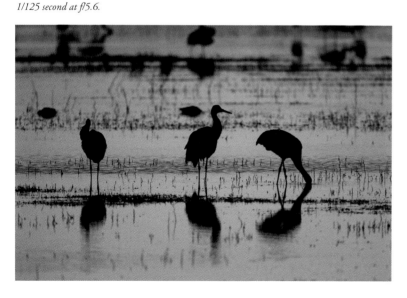

Exposure

• *Shoot Manual.* When shooting birds in flight, it is very easy to underexpose the subject against a brighter background. Using spot metering can also be difficult as the bird's position and size change rapidly. A preferred route is to use a matrix or evaluative manual reading for an average background. Then as the bird moves into view, it can generally be exposed properly against a brighter background.

• *Pan for Exposure.* For birds in-flight at sunset, intensity levels can change very rapidly. Set your manual exposure reading to an average for the desired background as above. Then follow the bird in the viewfinder until the exposure of your subject reaches that previously set for the background ambient. This ensures both subjects are properly exposed in rapidly changing lighting such as at sunset.

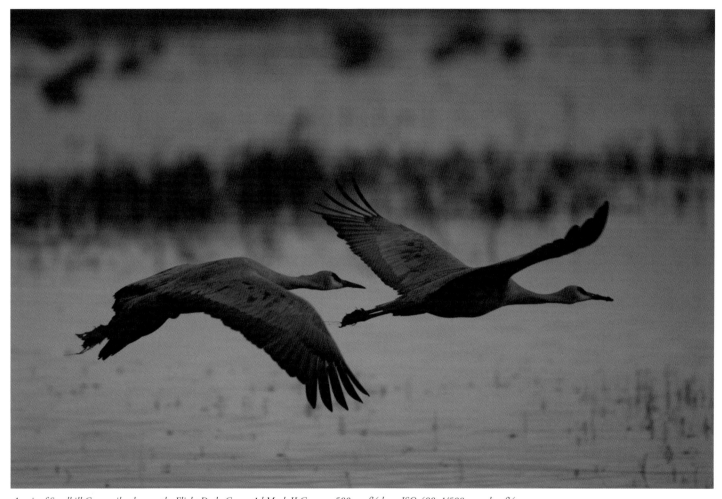

A pair of Sandhill Cranes silently cross the Flight Deck. Canon 1d Mark II Camera, 500mm f/4 lens, ISO 400, 1/500 second at f/4.

Just as the sandhills find their final resting spots for the night, suddenly from the north, thousands of Snow Geese erupt in one final push for the day. Converging on the Flight Deck, the sky is filled with thousands of birds in a chaotic, almost Biblical swarm. Against the vivid hues of the New Mexico sky, the Snow Geese quickly make their way to the water and quiet down for the night. Soon their silhouettes disappear into the night.

Low Light - Digital Noise
• *Go for Color.* When in doubt, go for color and force your subject to a silhouette. Often, less is more.
• *Resist using a high ISO.* Similar to film, high ISO settings result in images that are too "grainy". If you must, try the Adobe Photoshop plug-in DFINE by NIK to reduce luminance and chrominance noise.

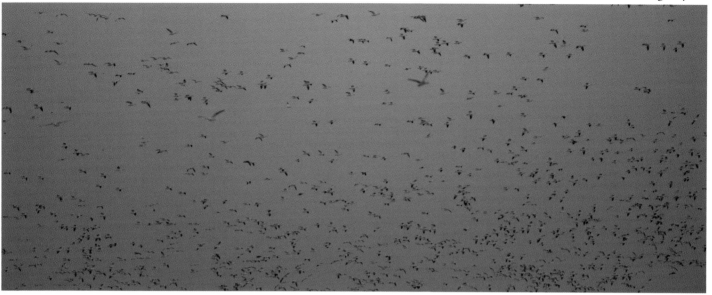

Thousands of Snow Geese are airborne for the nightly fly-in. Canon 1d Mark II Camera, 500mm f/4 lens, ISO 400, 1/400 second at f/4.

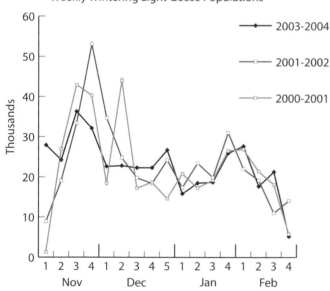

**Bosque del Apache National Wildlife Refuge
Weekly Wintering Light Geese Populations**

2003-2004

2001-2002

2000-2001

Snow Geese Fly-in

Snow Geese. Canon 1d Mark II Camera, 500mm f/4 lens, ISO 400, 1/250 second at f/4.

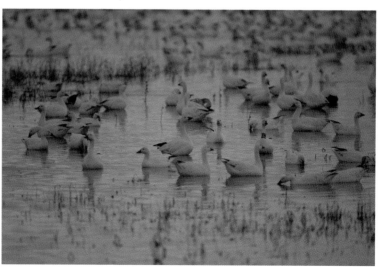

Between the third and fourth week of November, the refuge swells with light geese. Relatively flat until mid-January, geese stage briefly on the refuge during the 1st week of February before making their long journey north.

67

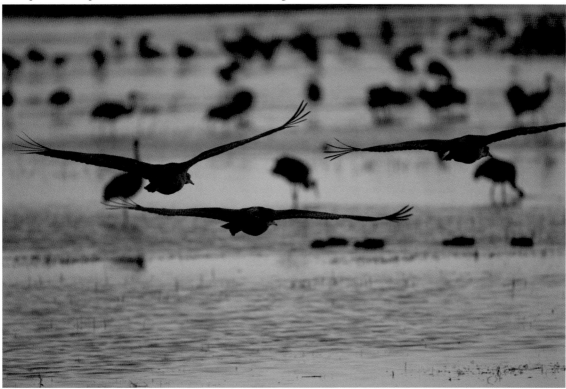

Sandhill Cranes. Canon 1d Mark II Camera,
500mm f/4 lens, ISO 800, 1/500 second at f/4.

Sandhill Crane on final
approach. Canon 1d Mark
II Camera, 500mm f/4 lens,
ISO 400, 1/640 second at f/4.

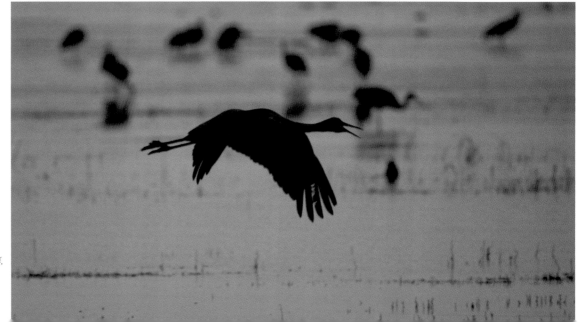

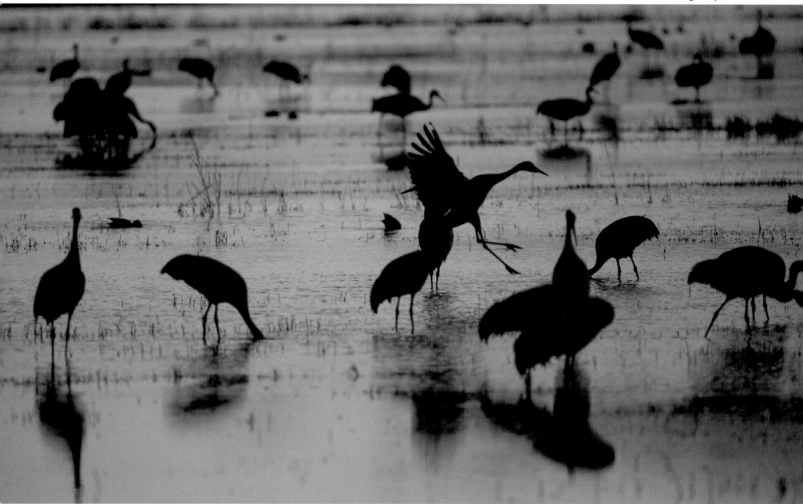

Canon 1d Mark II Camera, 500mm f/4 lens, ISO 400, 1/500 second at f/4.

Silhouettes

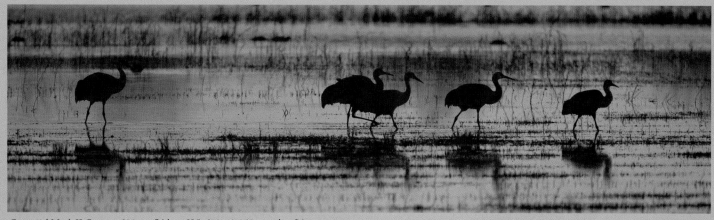

Canon 1d Mark II Camera, 500mm f/4 lens, ISO 400, 1/1250 second at f/4.

Socialization

Canon 1d Mark II Camera, 500mm f/4 lens, ISO 1600, 1/160 second at f/4.

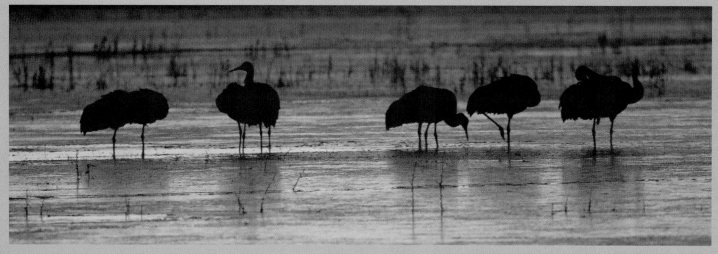

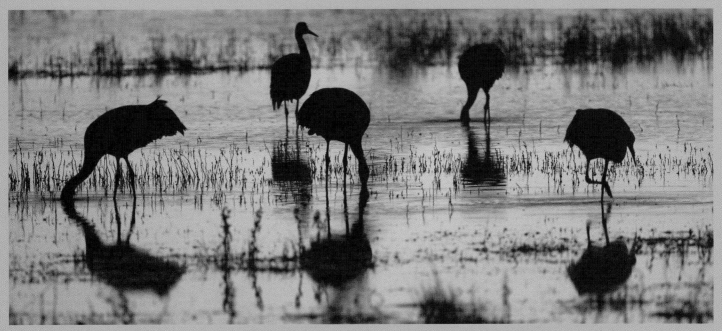

Canon 1d Mark II Camera, 500mm f/4 lens, ISO 1250, 1/500 second at f/4.

Digital Equipment

• *Megapixels vs. fps.* While both can be important, I have found that frames per second (fps) can be an advantage over the megapixel battle. Particularly for birds, fast action flight requires ultrafast autofocus and fps. Resolution, while important, is often secondary.

• *Bring Additional Storage.* At 8.5 fps and 8 MP or higher images, you can quickly fill a 2GB compact flash card. I use a portable image storage device, the Epson P-2000. With 40GB of storage space, I can offload 5000 images - usually 4-5 days worth of shooting.

Snow Goose. Canon 1d Mark II Camera, 500mm f/4 lens, ISO 1250, 1/250 second at f/4.

Snow Geese. Canon 1d Mark II Camera, 500mm f/4 lens, ISO 1600, 1/200 second at f/4.

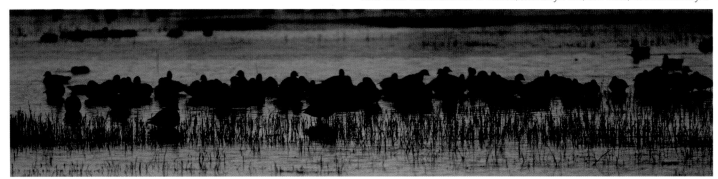

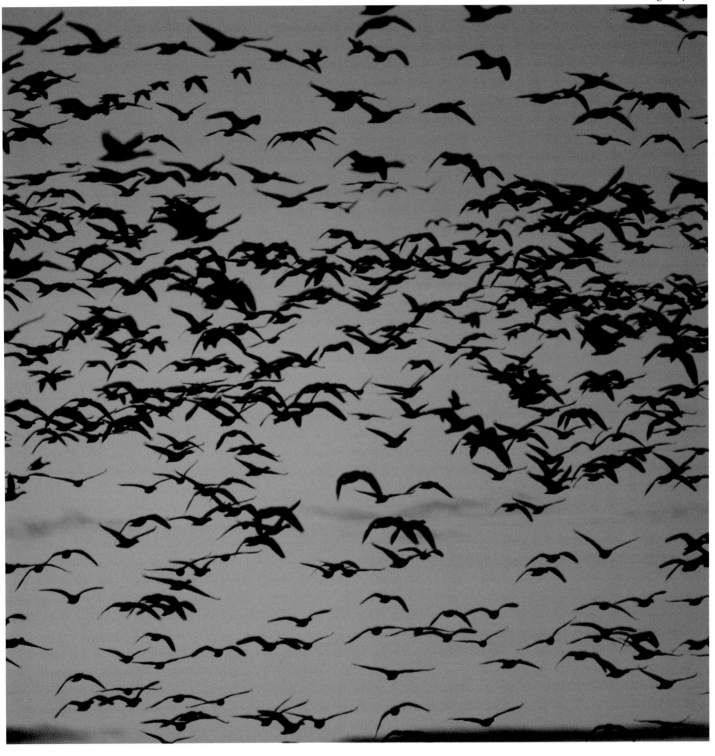

J.N. "Ding" Darling National Wildlife Refuge

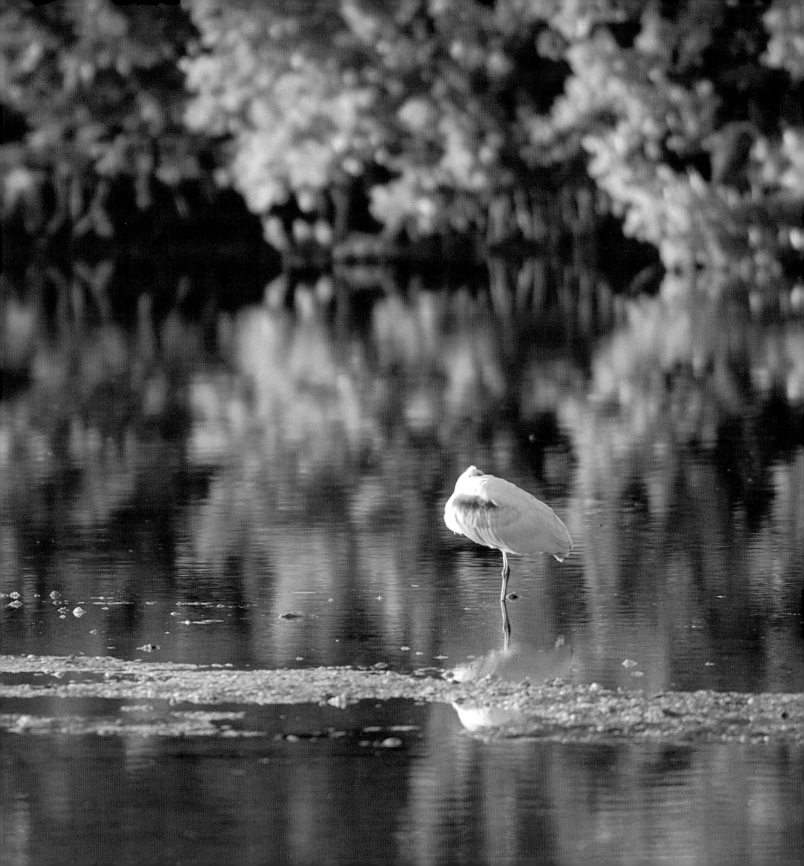

ALABAMA

FLORIDA

GEORGIA

ATLANTIC

OCEAN

Albany

Pensacola

Tallahassee

Jacksonville

Gainesville

Daytona Beach

Merritt Island NWR

Orlando

Clearwater
Largo
St. Petersburg

Tampa

West Palm Beach

J.N. "Ding" Darling NWR

Pompano Beach
Fort Lauderdale
Hollywood
Hialeah
Miami Beach
Miami
Kendall

GULF

OF

MEXICO

0 100 Miles

0 100 KM

Parallel scale at 28°N 0°E

Florida Birds

Sanibel Island is home to one of the largest undeveloped mangrove ecosystems in the United States. Shallow bays and tidal estuaries host a wide array of aquatic life that attract shorebirds such as Roseate Spoonbills, Osprey, egrets, herons, and a number of other species.

Discovered in 1513 by Jaun Ponce de Leon who was searching for the fountain of youth, Sanibel Island was also home to Calusa Indian settlements. The Calusa Indians thrived on an environment rich in shellfish and waterfowl.

Like many species in the last half of the 1800's to the 1930's, Roseate Spoonbills suffered greatly due to excessive hunting. Sought out for their vivid plumage, spoonbills were driven to the brink of extinction in 1935 with fewer than 200 mating pairs in Florida. The species rebounded and reached a peak of 1250 nesting pairs in 1979. However, since then, the species has again been on the decline.

Spoonbills depend heavily on wetlands for food. Over the years, urban developments have significantly impacted the Everglades eco-system and species like the spoonbill.

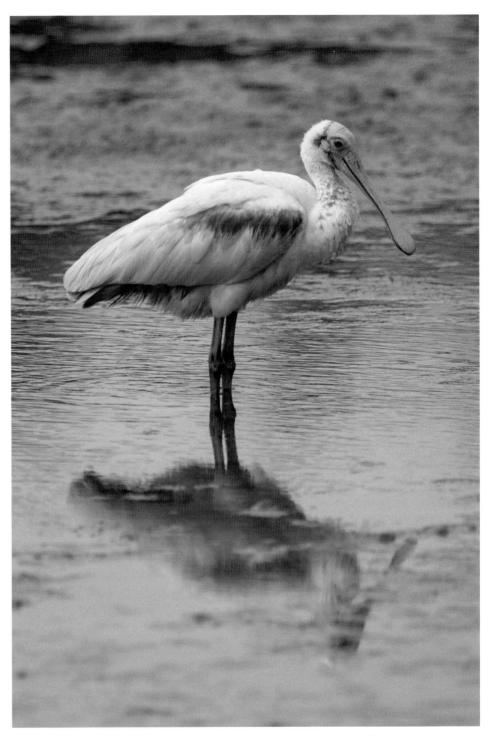

Roseate Spoonbill. Canon 1D Mark II Camera, 500mm f/4 lens, ISO 100, 1/640 second at f/6.3.

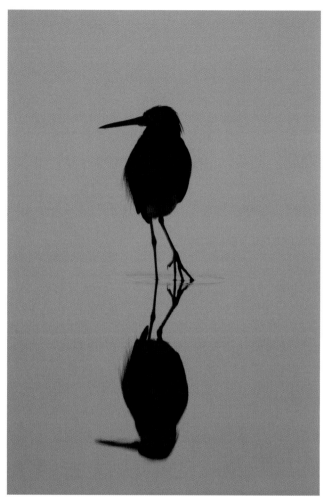

Tricolored Heron. Nikon D2H Camera, 500mm f/4 lens, 1.4x teleconverter (effectively 1050mm) ISO 200, 1/250 second at f/5.6.

Exposing for Highlights

•*Highlights.* Compared to film, digital cameras can be more sensitive to over-exposure of highlights. To prevent wash-out and loss of detail, review the histogram on your camera's display and verify it is not too heavily weighted to the right indicating a higher distribution of light or over-exposed pixels. If so, decrease the exposure and retake the image to balance the histogram. Exposing for highlights is a key element of digital photography.

American Alligator. Canon 1D Mark II Camera, 500mm f/4 lens, ISO 100, 1/400 second at f/5.6.

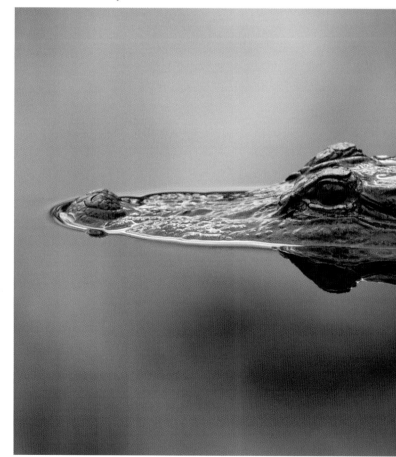

Burning less than 200 calories a day, an American Alligator is motionless waiting for the perfect moment on a quiet refuge waterway.

Reflections

Great Egret. Canon 1D Mark II Camera, 500mm f/4 lens, 1.4x teleconverter (effectively 910mm) ISO 100, 1/800 second at f/5.6.

Reflecting on the glassy surface of the water, a Great Egret displays bleeding plumage in early March.

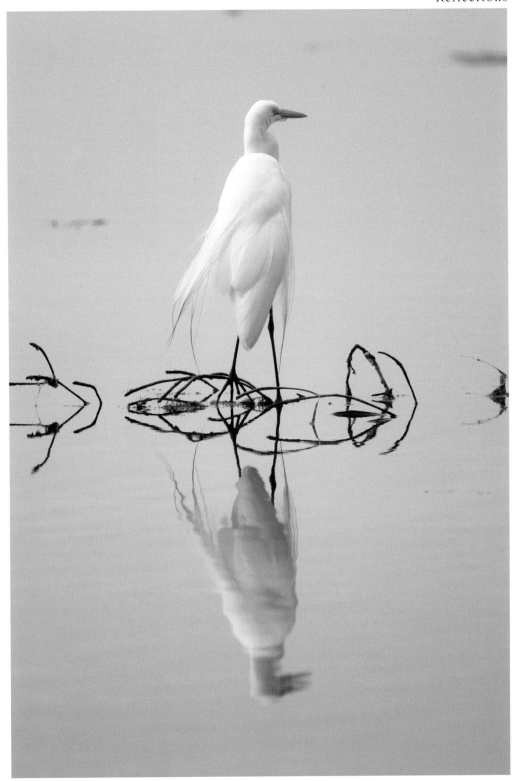

Tricolored Heron searches for fish and shrimp on the estuary. Canon 1D Mark II Camera, 500mm f/4 lens, 1.4x teleconverter (effectively 910mm) ISO 100, 1/500 second at f/7.1.

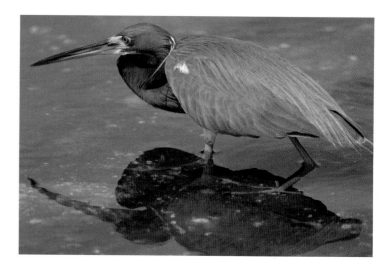

A Green Heron silently waits by an access road on the refuge. Canon 1D Mark II Camera, 500mm f/4 lens, 1.4x teleconverter (effectively 910mm) ISO 100, 1/60 second at f/5.6.

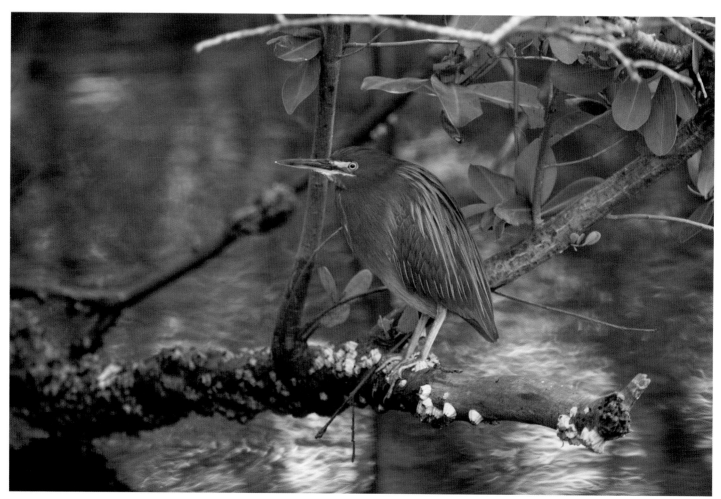

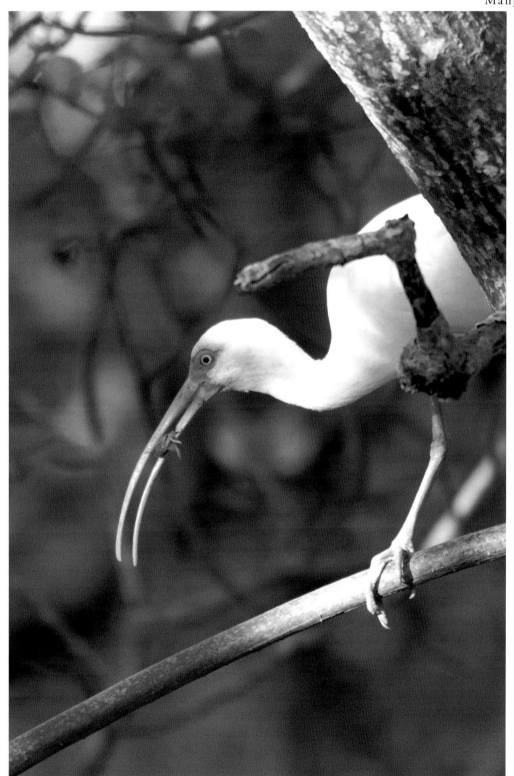

A White Ibis catches a crab in the mangrove. Nikon D2H Camera, 500mm f/4 lens, 1.4x teleconverter (effectively 1050mm) ISO 400, 1/30 second at f/5.6.

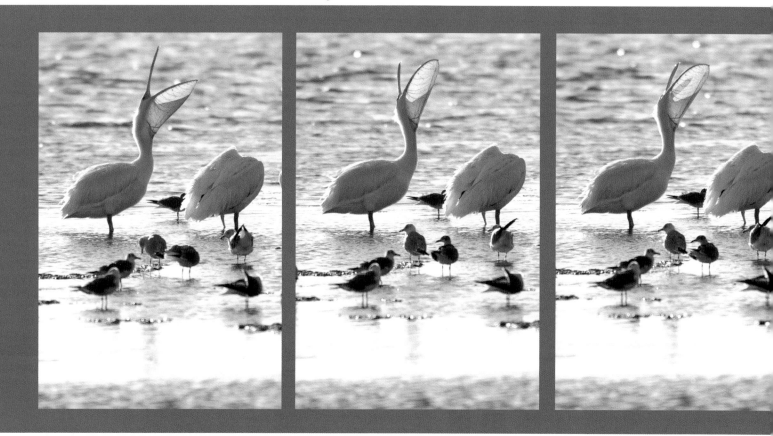

At 8 frames per second, an American White Pelican swings wildly in the late afternoon sun. Nikon D2H Camera, 500mm f/4 lens, 1.4x teleconverter (effectively 1050mm) ISO 200, 1/640 second at f/5.6.

Conservation

Established in 1945 as the Sanibel Island National Wildlife Refuge, the refuge was renamed in 1967 in honor of the legendary conservationist and editorial cartoonist Jay Norword "Ding" Darling. Today 6,300 acres of tidal estuaries and mangrove eco-systems allow White Ibis, Red Herons, spoonbills, and others the necessary habitat and protection to survive.

As head of the United States Biological Survey in 1934, the forerunner to the United States Fish and Wildlife Service, Darling worked to protect thousands of acres and species by launching the Federal Duck Stamp program. Hunters were now required to purchase a stamp, the proceeds of which went to the purchase of wetland habitats, critical to the protection of key species and migratory waterfowl. Darling not only changed the landscape of conservation in the United States, he set in motion a process that continues today to conserve and protect wetlands.

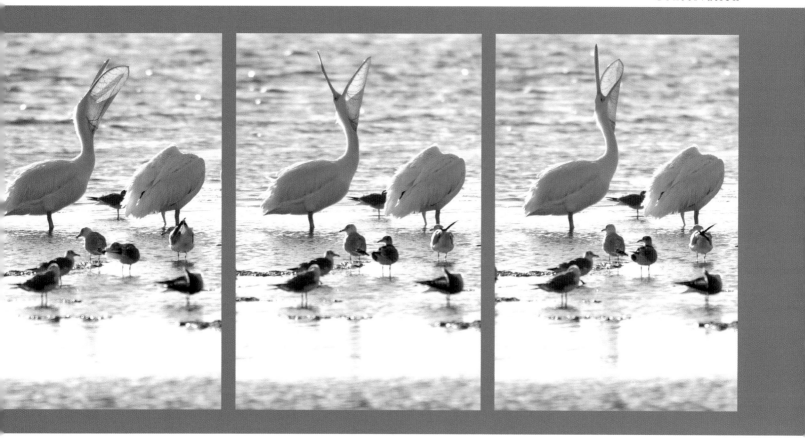

Darling was startled to learn in the 1940's that the State of Florida was attempting to sell 2,200 acres of pristine mangrove wetlands to land developers for $0.50/acre. Darling realized the importance of these tidal estuaries on key species such as spoonbills and arranged for the United States Fish and Wildlife Service to lease the land to form the Sanibel Island National Wildlife Refuge.

During his leadership of the U.S. Biological Survey, Darling also used his skills as a cartoonist to craft the Blue Goose logo, the National symbol of the refuge system. Rachel Carson author of *Silent Spring*, scientist and chief editor for the U.S. Fish and Wildlife Service from 1932- 52, wrote of the emblem "Wherever you meet this sign, respect it. It means that the land behind the sign has been dedicated by the American people to preserving, for themselves and their children, as much of our native wildlife as can be retained along with our modern civilization."

Sensor Dust

• *Sensor Dust*. Often new digital cameras come with dust on the CMOS or CCD sensor in addition to collecting particles when in the field. Exposing at f/16 or smaller will reveal any contaminants on the sensor.

• *Minimize Dirt*. Limit changing your lens in high dust or windy environments. Keep lens caps clean and free of contaminants.

• *CCD or CMOS Cleaning*. Few good options exist today. If you feel confident enough to try this yourself, a Canadian company called Visible Dust markets a fine electro-static brush to attract and remove offending particles.

Large numbers of Great Egrets fish the refuge feeding on the abundant aquatic wildlife.

Great Egret with a shrimp. Canon 1D Mark II Camera, 500mm f/4 lens, 1.4x teleconverter (effectively 910mm) ISO 100, 1/500 second at f/5.6.

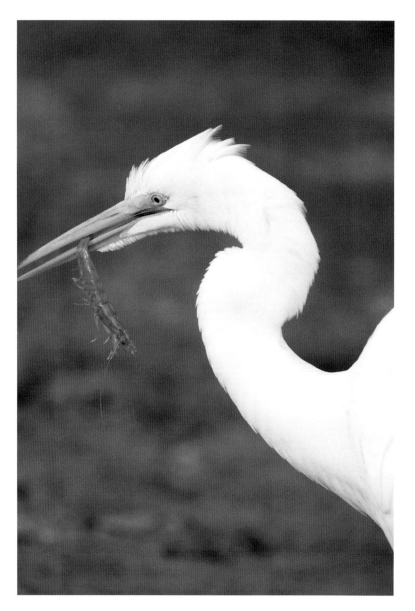

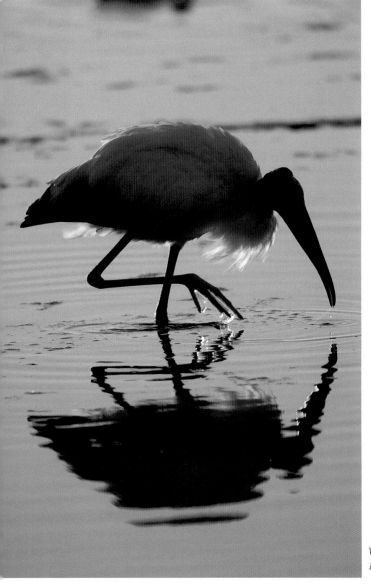

Listed as endangered by the US Fish and Wildlife Service, a lone Wood Stork searches a tidal estuary for food. Wood Storks are an excellent eco-system indicator due to their extensive use of freshwater and estuarine wetlands. Nearly 9,000 nesting pairs were counted in 1935. Today, less than 500 pairs are typically seen in southern Florida.

Wood Stork. Nikon D2H Camera, 500mm f/4 lens, ISO 200, 1/1250 second at f/4.

Shorebirds

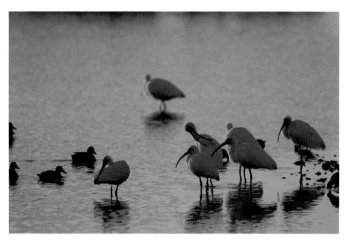

White Ibis. Nikon D2H Camera, 500mm f/4 lens, ISO 200, 1/640 second at f/4.

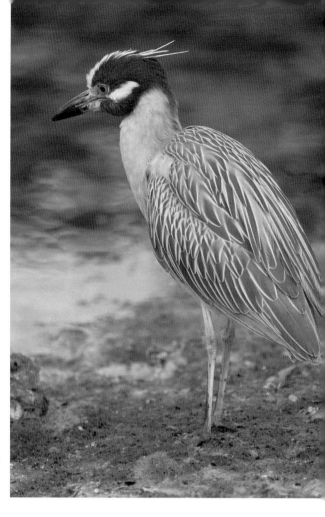

Yellow-crowned Night Herons frequent the mangrove and shoreline along with an extensive colony of White Ibis. The curved bill of the ibis allows for deep penetration into the muddy surface of the estuary to feed.

Yellow-crowned Night Heron. Canon 1D Mark II Camera, 500mm f/4 lens, 1.4x teleconverter (effectively 910mm) ISO 100, 1/320 second at f/5.6.

White Ibis at sunset. Nikon D2H Camera, 500mm f/4 lens, ISO 200, 1/1250 second at f/4.

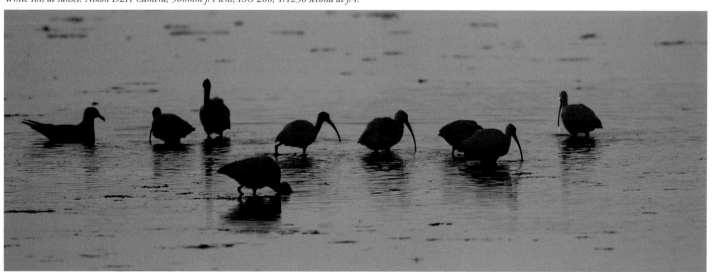

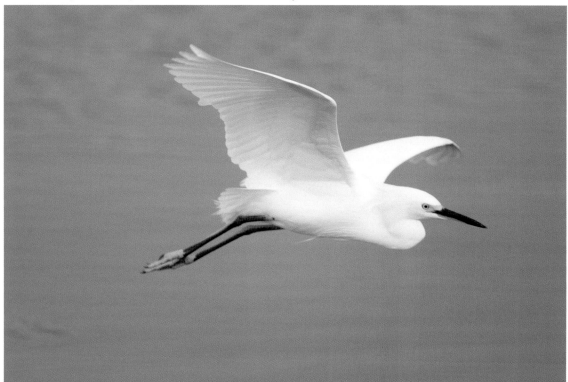

Snowy Egret. Canon 1D Mark II Camera, 500mm f/4 lens, 1.4x teleconverter (effectively 910mm) ISO 100, 1/500 second at f/5.6.

Snowy Egrets and Tricolored Herons frequent the refuge often competing for fish and shrimp along the shoreline. The bright green highlights on the back of the legs of the Snowy Egret are indicative of a juvenile. Flying back and forth along the shoreline, each plays a game of cat and mouse looking to steal the other's catch.

Tricolored Heron. Canon 1D Mark II Camera, 500mm f/4 lens, 1.4x teleconverter (effectively 910mm) ISO 100, 1/800 second at f/5.6.

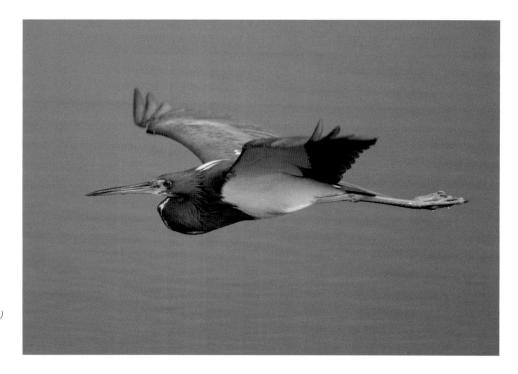

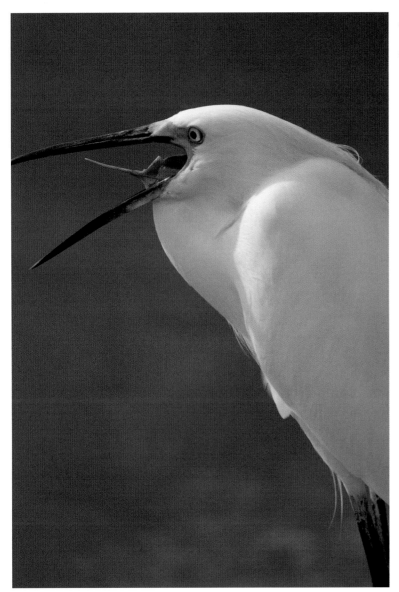

Snowy Egret. Canon 1D Mark II Camera, 500mm f/4 lens, 1.4x teleconverter (effectively 910mm) ISO 400, 1/5000 second at f/5.6.

A Snowy Egret takes a big yawn in the late afternoon after several hours of fishing the shoreline.

Osprey. Canon 1D Mark II Camera, 500mm f/4 lens, 1.4x teleconverter (effectively 910mm) ISO 400, 1/250 second at f/5.6.

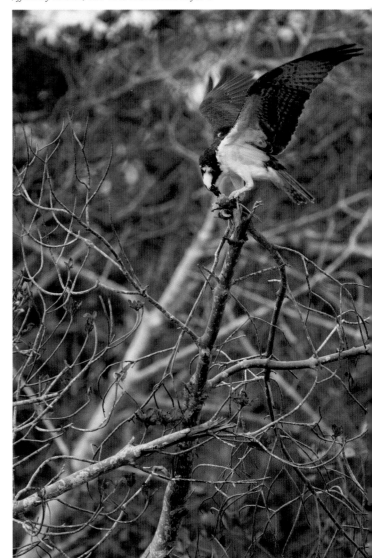

Water Quality

Osprey are another strong indicator of eco-system health and are plentiful on the refuge. Pulling fish from the estuary, an Osprey precariously feeds atop a tree branch.

Sherburne
National W
Refuge

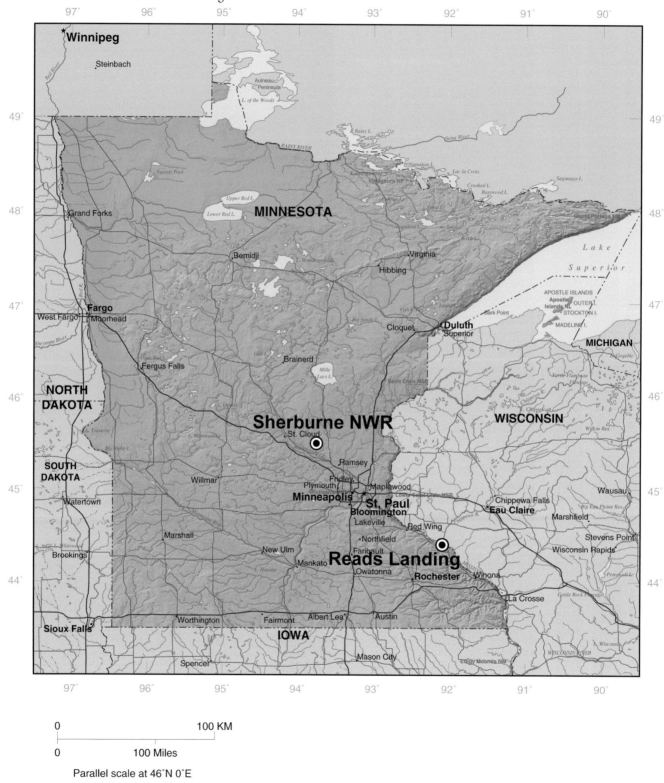

0 100 KM

0 100 Miles

Parallel scale at 46°N 0°E

Loons

In the spring and summer, Common Loons take up residence on the Sherburne National Wildlife Refuge in central Minnesota. Solitary and territorial, loons nest near the waters edge. While a powerful swimmer, they are virtually helpless on land and need shoreline for survival. The marshes and lakes of Sherburne National Wildlife Refuge provide a critical source of open shoreline and ample fish to raise new generations. Minnesota is home to over 12,000 loons in the summer, the largest concentration in the United States. Since loons dive for their food, water clarity is a critical factor in being able to see fish under the water.

Common Loon. Nikon D2H Camera, 500mm f/4 lens, 2.0x teleconverter (effectively 1500mm) ISO 200, 1/250 second at f/8.

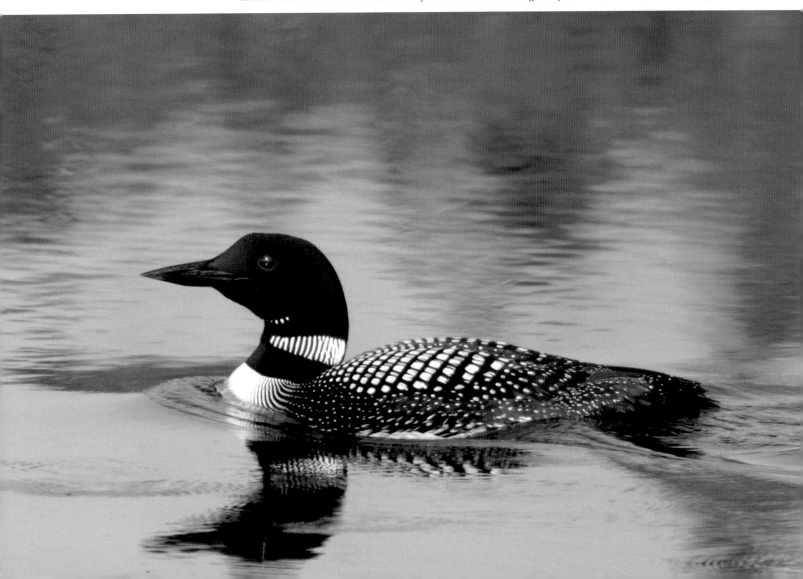

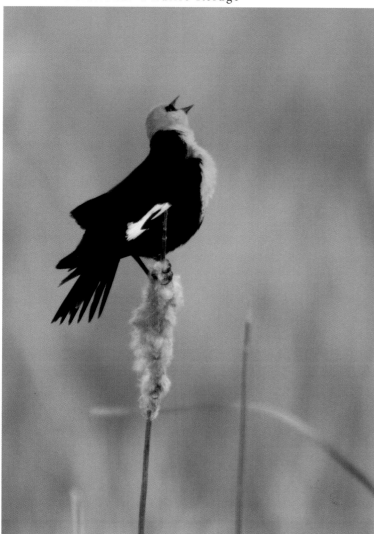

Yellow-headed Blackbird. Nikon D2H Camera, 500mm f/4 lens, 1.4x teleconverter (effectively 1050mm) ISO 200, 1/200 second at f/5.6.

With his head thrown upward and a loud call, a Yellow-headed Blackbird sings loudly on the refuge.

Closing in on your Subject

• *Effective Magnification.* Digital SLR cameras often have the advantage of reduced image plane sizes. This results in effective magnifications of 1.5x (Nikon D2H) or 1.3x (Canon 1D Mark II). A 500mm lens on the Nikon D2H has an effective focal length of 750mm at f/4. Adding a 1.4x teleconverter to a film camera results in a 1-stop reduction at 1050mm. Typically, digital SLR cameras can achieve higher levels of magnification and faster shutter speeds than their film counterparts.

Throughout the spring and summer, two pairs of Sandhill Cranes can be regularly observed. Rust stained, this sandhill quietly moves through the marsh.

Refuge Marsh

Sherburne National Wildlife Refuge resides within the St. Francis River Valley at the edge of the boreal forest in Minnesota. Prior to the Homestead Act of 1870, this undeveloped, wild and open land was highly regarded for its richness of waterfowl and wildlife. As development of the land expanded for agriculture at the turn of the century, wetlands diminished and crops such as wild rice that once supported thousands of migratory birds vanished, threatening waterfowl populations.

In 1940, conservation efforts gained momentum to restore these lands and the wildlife that once populated them. By 1965, that dream was finally realized with over 30,665 acres of protected wetlands set aside as a National Wildlife Refuge. Today, the refuge supports a large number of Cormorants, Bald Eagles, River Otters, rare Trumpeter Swans, raptors, and a wide range of birds and other migratory waterfowl.

Sandhill Crane. Nikon D2H Camera, 500mm f/4 lens, 1.4x teleconverter (effectively 1050mm) ISO 200, 1/160 second at f/5.6.

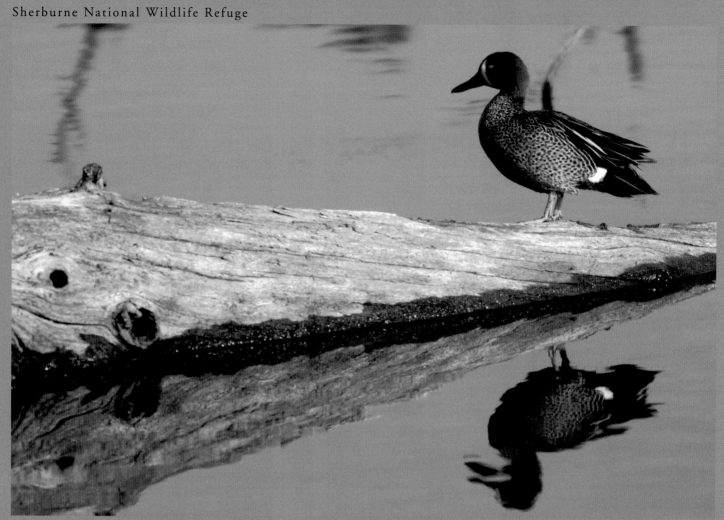

A Blue-winged Teal takes an early morning nap in the Sherburne National Wildlife Refuge.

Nikon D2H Camera, 500mm f/4 lens, 1.4x teleconverter (effectively 1050mm) ISO 200, 1/500 second at f/5.6.

Spring Wildlife

With the opening of the refuge each spring, thousands of birds are also in-flight returning from wintering locations. After the long haul, Blue-winged Teals spread out across the refuge occupying small ponds and taking a well needed rest. Within North America, the Blue-winged Teal population has remained fairly stable. Since 1955, the population has averaged 4.4 million, peaking as high as 7.4 million in 2000. In 2004, approximately 4.1 million birds were estimated. In the spring, Sherburne typically hosts several hundred.

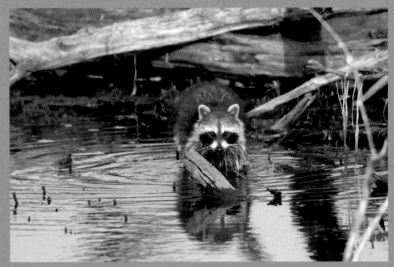

A raccoon searches the marsh bottom for crayfish. Nikon D2H Camera, 500mm f/4 lens, 1.4x teleconverter (effectively 1050mm) ISO 200, 1/320 second at f/5.6.

A rare Trumpeter Swan sits on the nest. Nikon D2H Camera, 500mm f/4 lens, 1.4x teleconverter (effectively 1050mm) ISO 200, 1/750 second at f/5.6.

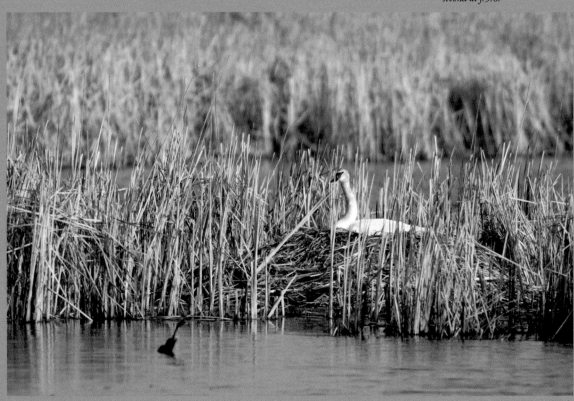

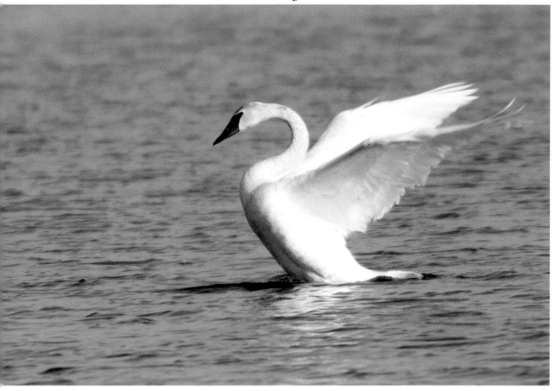

Nikon D2H Camera, 500mm f/4 lens, 1.4x teleconverter (effectively 1050mm) ISO 200, 1/350 second at f/8.

Loosening up for flight, a Trumpeter Swan spreads its massive wings.

A common sight on the refuge, Bald Eagles return each year to the refuge.

Yellow-headed Blackbird. Nikon D2H Camera, 500mm f/4 lens, 1.4x teleconverter (effectively 1050mm) ISO 200, 1/1250 second at f/5.6.

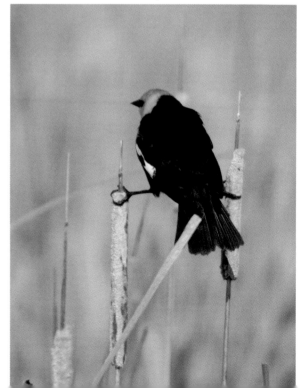

Rare Birds

There are three main populations of Trumpeter Swans, the Pacific, Rocky Mountain, and Interior. The Interior population comprises Minnesota, Michigan, Wisconsin, Ohio, Ontario, Iowa, Nebraska, South Dakota, and New York.

Within the Interior, the population was estimated at 2,430 in 2000, roughly 10% of the total Trumpeter Swan population in North America. In recent years Trumpeter Swans continue to make a substantial comeback. This was not always the case. In 1968, the entire Pacific, Rocky Mountain, and Interior population was a mere 3,722 with as few as 68 in the Interior. National Wildlife Refuges such as Sherburne afford critical nesting habitat for species on the brink to recover.

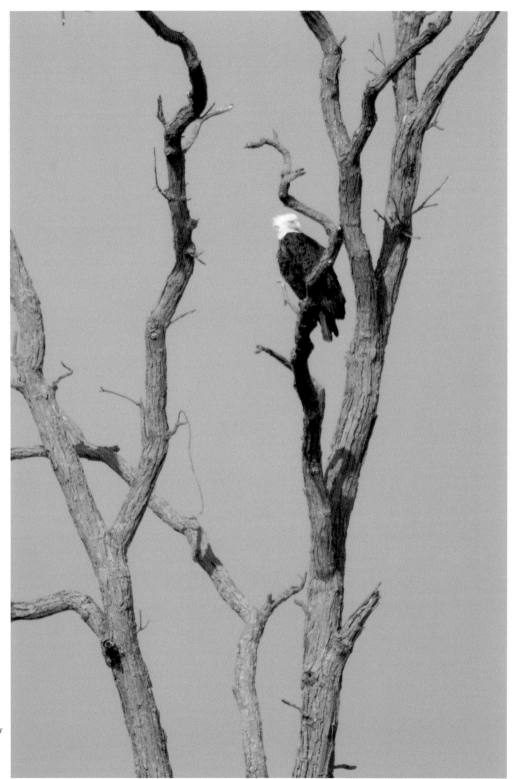

*Bald Eagle. Nikon
D2H Camera,
500mm f/4 lens, 2.0x
teleconverter (effectively
1500mm) ISO 200,
1/500 second at f/8.*

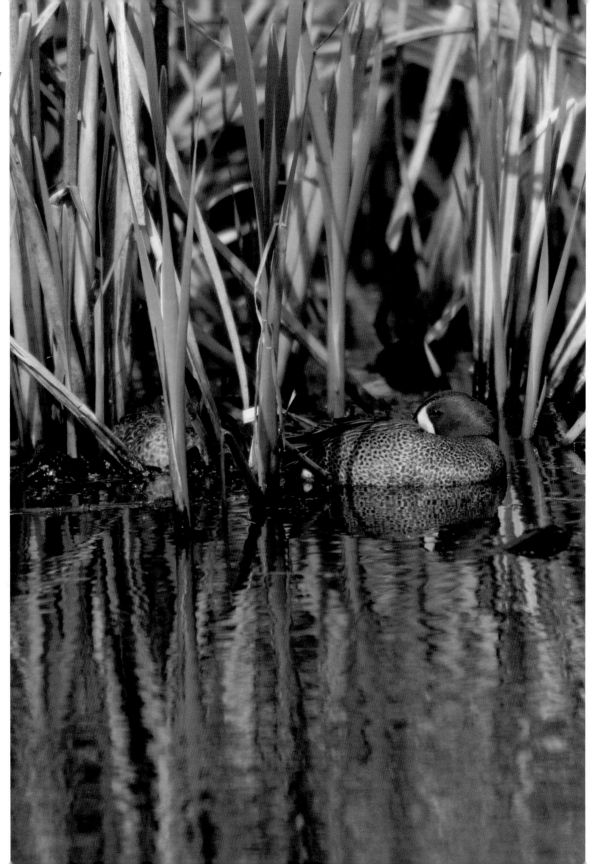

Blue-winged Teal. Nikon D2H Camera, 500mm f/ 4 lens, 1.4x teleconverter (effectively 1050mm) ISO 200, 1/800 second at f/5.6.

Blending with the Environment

On first pass, one might be inclined to not see a Great Blue Heron among the dead tree branches of the marsh. Likewise, a sleeping Blue-winged Teal quickly blends into the lush reeds. These are important elements of survival.

A key skill in discerning the presence of birds and waterfowl begins with understanding their habitat. For example, for Great Blue Herons to enjoy a healthy population, they need to nest near water and trees. Heron rookeries with both these elements are common in portions of the Midwest. However, fishing boats, shoreline development, and hunters can easily disturb the hatchlings who often fall from the nest. Many heron rookeries have well established keep-out zones so as to not disturb yearlings while still in the nest.

Beyond human intervention, a significant threat to Great Blue Heron populations are Bald Eagles who often prey on hatchlings. At Sherburne, this life and death struggle plays out each day.

Great Blue Heron on watch. Nikon D2H Camera, 500mm f/4 lens, 1.4x teleconverter (effectively 1050mm) ISO 200, 1/800 second at f/5.6.

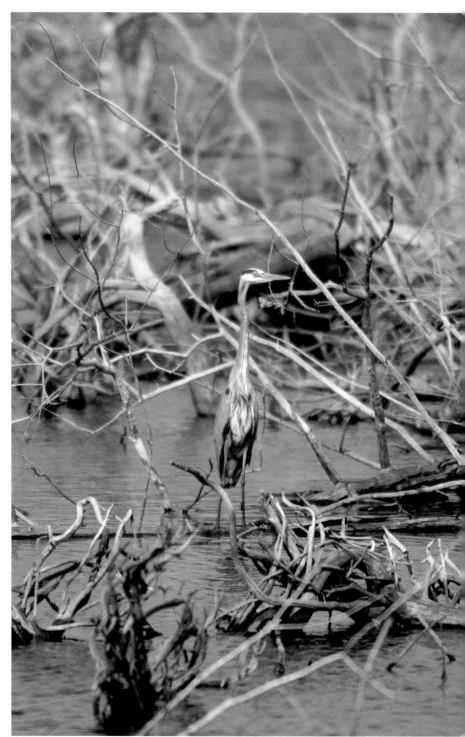

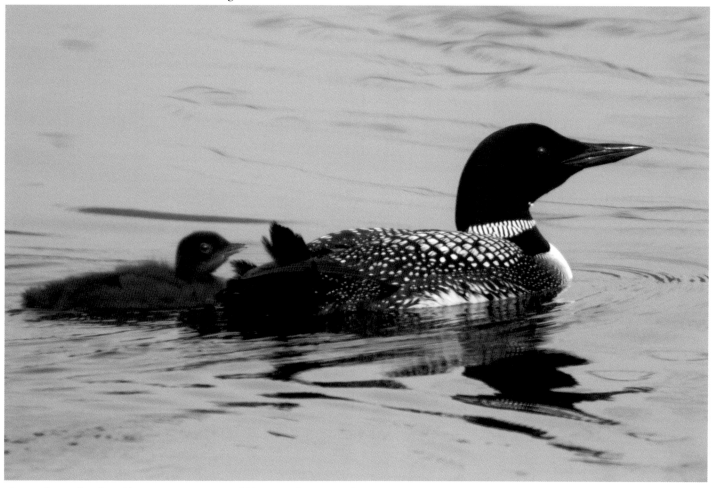

Common Loon and yearling. Nikon D2H Camera, 500mm f/4 lens, 2.0x teleconverter (effectively 1500mm) ISO 200, 1/250 second at f/8.

Renewal

In the summer, young loons and Trumpeter Swans venture out with their parents for their first fishing experience. The relationships between parents and siblings are strong. While one loon dives below, the other stays on top with the baby in constant contact. Each parent takes turns capturing and feeding fish to the yearlings. Occasionally, the fish provided is simply too big.

In a rare sight, a Trumpeter Swan keeps a close watch on a new generation of swans. As one swan reaches below the water to pull up vegetation, the other keeps a careful eye on the flock. Nearby, Bald Eagles perch above the refuge watching for hours.

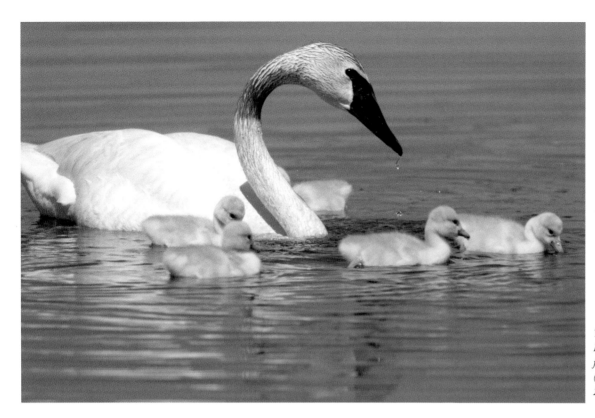

Trumpeter Swans. Nikon D2H Camera, 500mm f/4 lens, 1.4x teleconverter (effectively 1050mm) ISO 200, 1/250 second at f/5.6.

Common Loons. Nikon D2H Camera, 500mm f/4 lens, 2.0x teleconverter (effectively 1500mm) ISO 200, 1/400 second at f/8.

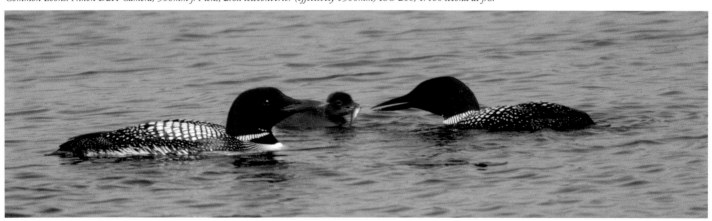

Mid-Summer

As the hot summer months of July and August approach, Green Herons and Red-tailed Hawks seem to take on a wider presence on the refuge. Both summer residents, each perches on dead marsh trees and attends to the business of preening and scanning the refuge for prey.

Red-tailed Hawk. Nikon D2H Camera, 500mm f/4 lens, 2.0x teleconverter (effectively 1500mm) ISO 200, 1/500 second at f/8.

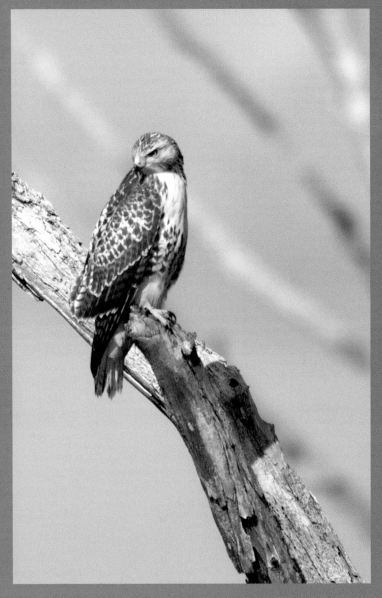

File Storage

• *Storage and Management.* Unlike processed film, digital images can quickly fill the hard drive on your computer. It is important early on to get organized with coded file names. For example: sbh0104_1738.NEF, means Sherburne, heron, 1st image in 2004, 1738 is the Nikon Raw file designation number. Rename only those images that have future potential. Delete or move offline all others.

Green Heron. Nikon D2H Camera, 500mm f/4 lens, 2.0x teleconverter (effectively 1500mm) ISO 200, 1/200 second at f/8.

Wood Ducks

Sherburne National Wildlife Refuge is the perfect environment for Wood Ducks to breed and raise their young. In the wetlands and secluded marsh waterways, newly minted Wood Ducks occasionally work their way near refuge access roads. Unlike adults, they often are much more tolerant of their surroundings having not experienced the hunting season. Conversely, mature adults will immediately take to flight when approached. Central Minnesota is prime breeding ground for Wood Ducks with wintering ranges centered in Louisiana and the southeastern United States.

Wood Duck. Nikon D2H Camera, 500mm f/4 lens, 2.0x teleconverter (effectively 1500mm) ISO 200, 1/400 second at f/8.

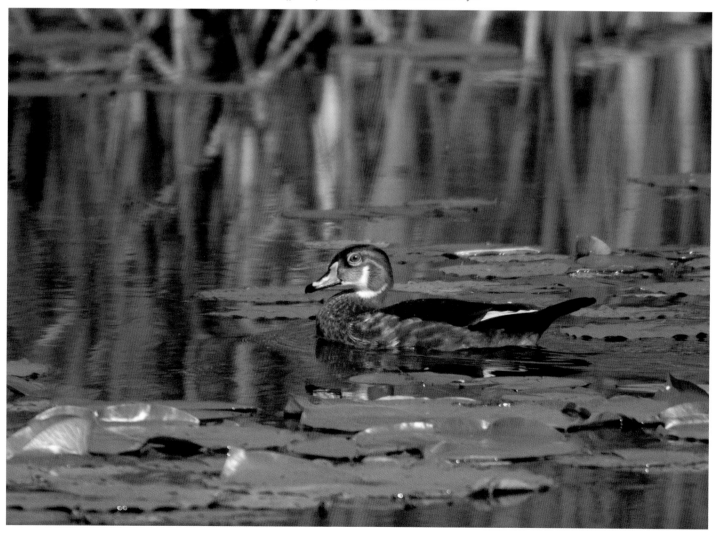

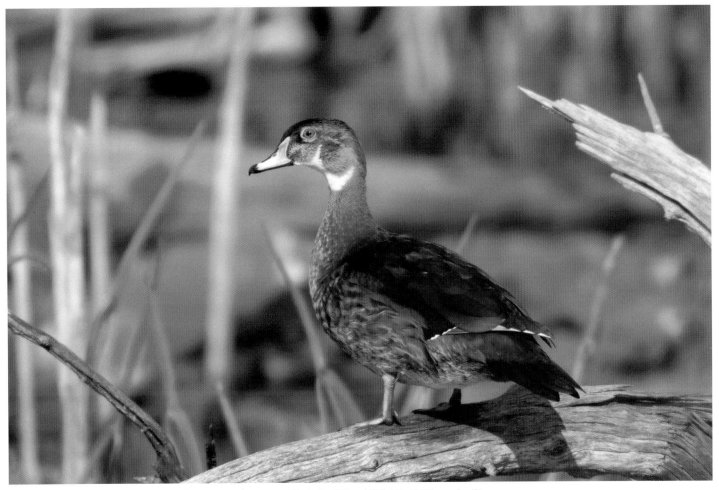

Wood Duck. Nikon D2H Camera, 500mm f/4 lens, 2.0x teleconverter (effectively 1500mm) ISO 200, 1/400 second at f/8.

Within Minnesota it is estimated that 100,000 Wood Ducks nest each year. Nearly wiped out due to loss of habitat in 1973, Wood Ducks have also made a substantial recovery due in part to artificial nest boxes, advances in clean water, and increased habitat afforded by our National Wildlife Refuge System. Due to these conservation efforts, today the Wood Duck is one of Minnesota's most abundant birds. In nearby Wisconsin, the population has also grown, steadily approaching 115,000 birds in 2004. In 1973, the population was estimated at roughly 7,000.

D-SLR Histograms

• *Histogram.* The histogram feature on typical D-SLR LCD monitors is an excellent way to review images for clipping of highlights and shadows.

• *LCD Monitor Cover.* Add a plastic screen protector to your LCD monitor to protect from scratches and glare. Thin optical films are easily applied, replaceable, and very inexpensive.

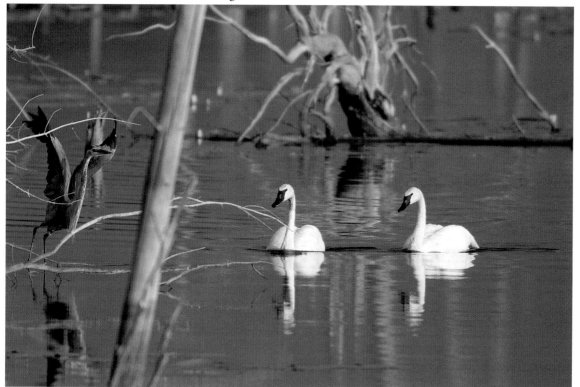

Nikon D2H Camera, 500mm f/4 lens, 1.4x teleconverter (effectively 1050mm) ISO 200, 1/1000 second at f/5.6.

As a male-female pair of Trumpeter Swans approaches, a Great Blue Heron is spooked into flight.

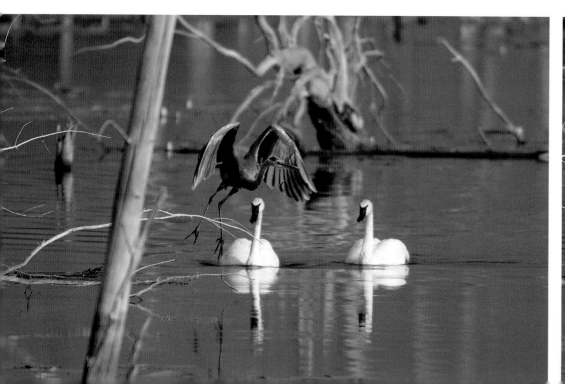

Trumpeter Swans

Like many other species at the turn of the century, over-hunting and pollution brought Trumpeter Swans to the brink of extinction. Within the continental United States, Minnesota, Michigan, Iowa, and Ohio generally represent the greatest concentrations of swans. However, within North America, Alaska has had the highest concentration with 75% of the total population.

The largest swan in North America, Trumpeter Swans have a wingspan of over 80 inches. By comparison, the Great Blue Heron has on average a wingspan of 72 inches but weighs a mere 5.3 lbs versus the trumpeter swan at 23 lbs. This difference in weight can easily be seen as herons have an almost vertical take-off while swans need appreciable open water and a running start for take-off. While Trumpeter Swans have made a remarkable comeback, continued loss of habitat, changes in migration routes, and lead poisoning from fishing tackle continue to put pressure on the population. Refuges such as Sherburne afford a stable environment for species such as Trumpeter Swans to return to each year.

A Great Blue Heron launches into flight at 8 frames per second. Nikon D2H Camera, 500mm f/4 lens, 1.4x teleconverter (effectively 1050mm) ISO 200, 1/1000 second at f/5.6.

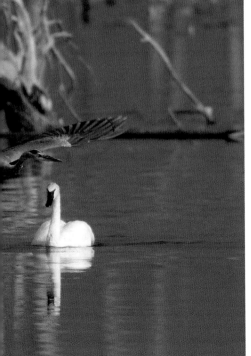
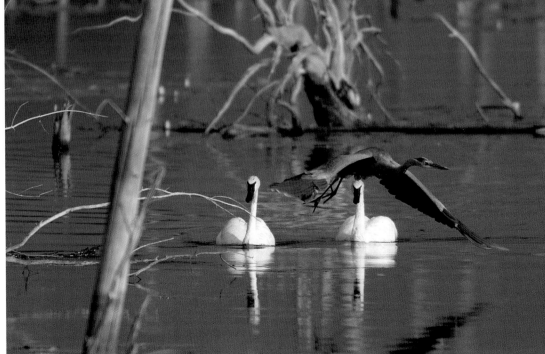

Sherburne National Wildlife Refuge

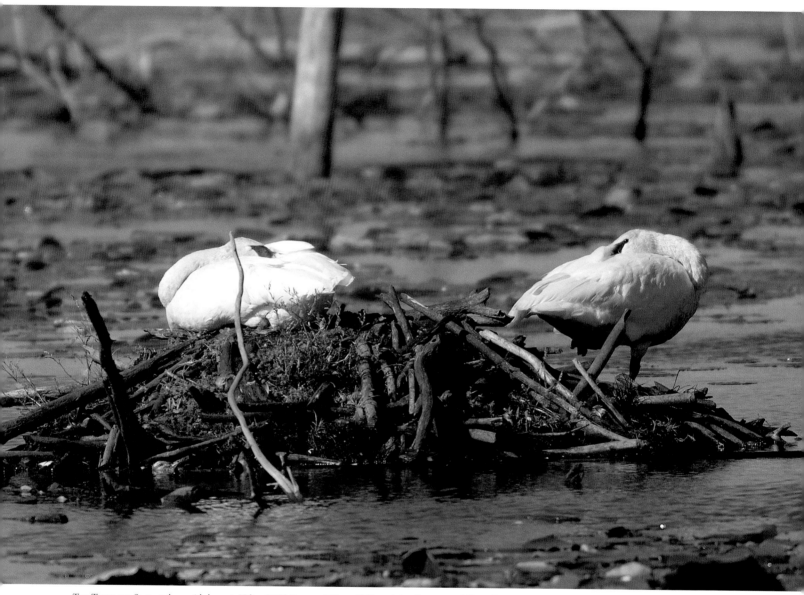

Two Trumpeter Swans take a mid-day rest. Nikon D2H Camera, 500mm f/4 lens, 1.4x teleconverter (effectively 1050mm) ISO 200, 1/1600 second at f/5.6.

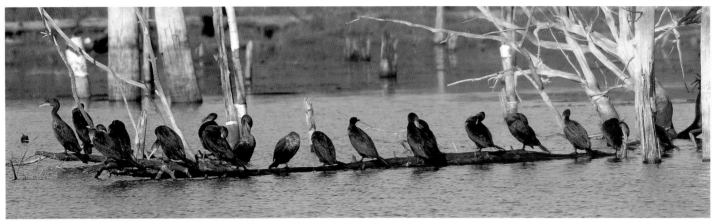

Double-crested Cormorants. Nikon D2H Camera, 500mm f/4 lens, 1.4x teleconverter (effectively 1050mm) ISO 200, 1/800 second at f/6.3.

Double-Crested Cormorants

As late summer approaches, herons, Double-crested Cormorants, and Trumpeter Swans remain scattered across the refuge. In a typical summer, the refuge hosts twenty five to fifty cormorants.

Within North America, the cormorant population is estimated at over 2 million. While improvements in water quality, reductions in DDT contaminants, addition to the Migratory Bird Treaty Act in 1972, and increased availability of food have helped the species expand since 1970, this expansion has come at the cost of a significant environmental impact. Namely, cormorants not only compete with loons, herons, and swans for fish, they also compete with humans. This has resulted in environmental impact statements from the U.S. Fish and Wildlife Service suggesting the necessity to head off an exploding population to stem the economic impact to fish industries.

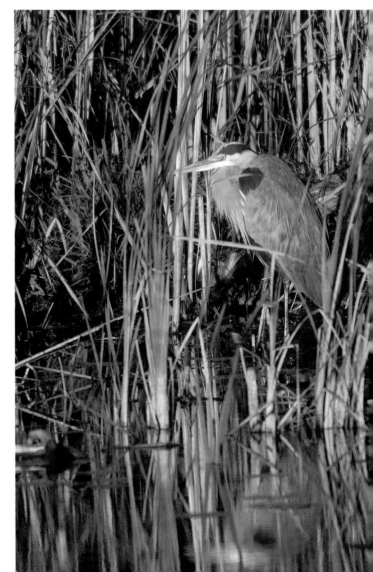

Great Blue Heron. Nikon D2H Camera, 500mm f/4 lens, 1.4x teleconverter (effectively 1050mm) ISO 200, 1/800 second at f/5.6.

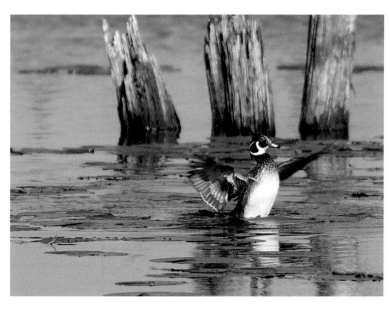

Wood Duck. Nikon D2H Camera, 500mm f/4 lens, 1.4x teleconverter (effectively 1050mm) ISO 200, 1/800 second at f/6.3.

Trumpeter Swan. Nikon D2H Camera, 500mm f/4 lens, 1.4x teleconverter (effectively 1050mm) ISO 200, 1/1250 second at f/6.3.

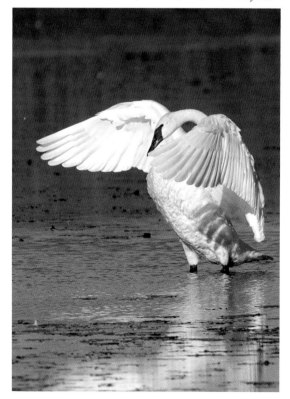

Competition

While improvements in water quality and the increase in Great Lakes fish populations have been beneficial to sporting and fish industries, it also has been a significant factor driving cormorant expansion. Specifically, during winter cormorants often feed on catfish crops in southern states inflicting economic hardships and compromising sport fishing. Returning in the spring to the Mississippi and Great Lakes region, they again find abundant fish and have been linked to significant declines in fish populations. Cormorants also compete with herons, loons, egrets, and other birds for nesting sites. Heavy concentrations of the birds also adversely affect water quality.

Unfortunately while conservation efforts have increased cormorant and other waterfowl populations, it has placed this species on a collision course with mankind.

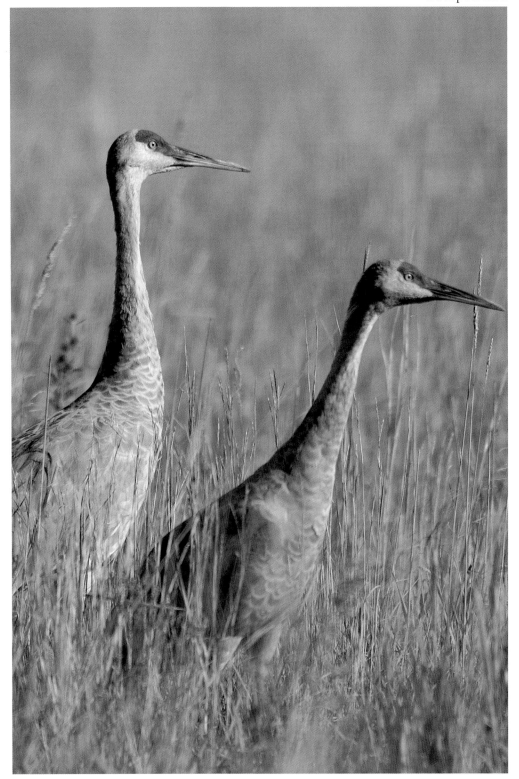

Sandhill Cranes. Nikon D2H Camera, 500mm f/4 lens, 1.4x teleconverter (effectively 1050mm) ISO 200, 1/640 second at f/6.3.

At the Center

Sherburne National Wildlife Refuge is home to a diverse array of waterfowl and migratory birds. Three species, Trumpeter Swans, Double-crested Cormorants, and Bald Eagles often are at the center of a number of environmental and conservation concerns.

During the summer as loons and other birds raise their young, unknown to them is the often up and down struggle to find balance between government agencies and environmental groups. Our National Wildlife Refuge system allows these birds to find a stable environment in the midst of political whirl-winds.

Upper Mississippi River National Wildlife Refuge

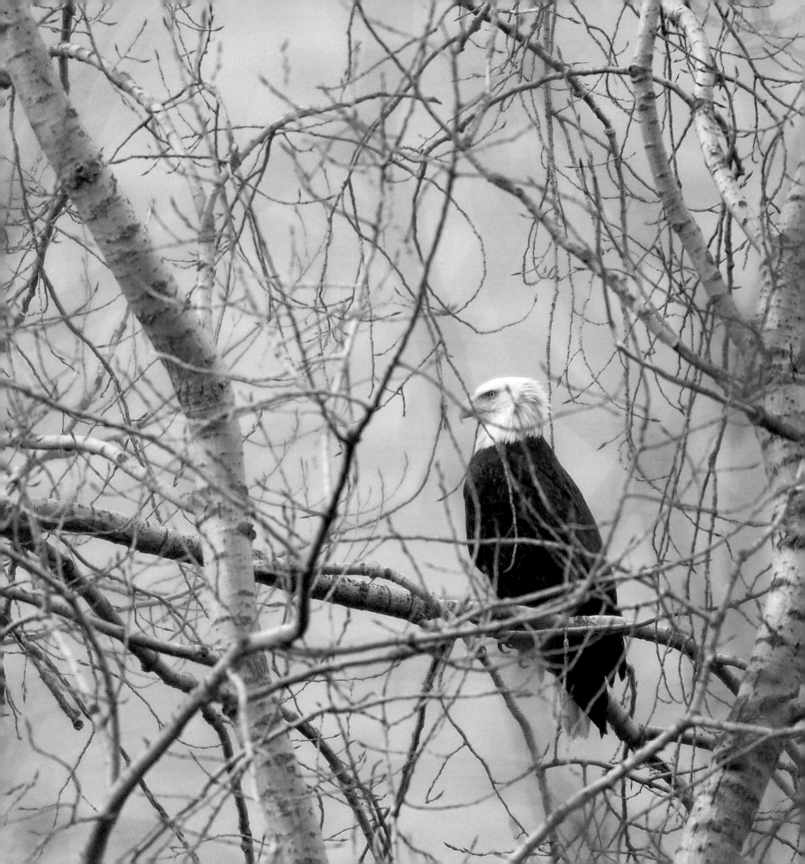

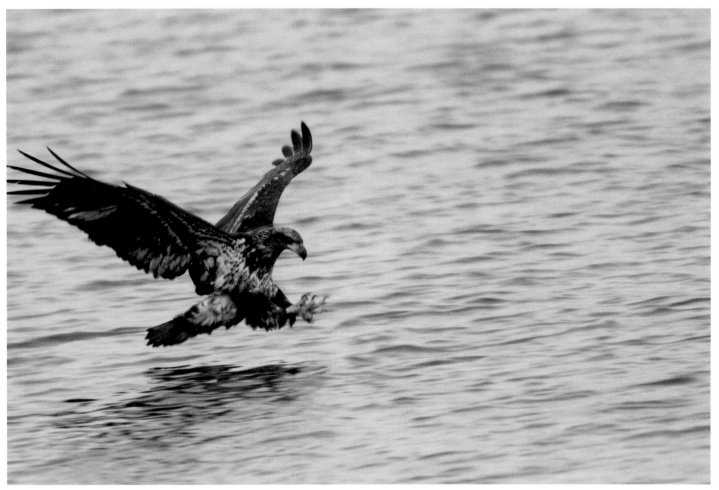

Juvenile Bald Eagle. Nikon D2H Camera, 500mm f/4 lens, 1.4x teleconverter (effectively 1050mm) ISO 400, 1/180 second at f/5.6.

In Search of Open Water

As winter sets in, Bald Eagles breeding in the upper midwest during the spring and summer are forced south in search of open water. As tributaries freeze, migration routes are funneled along the larger open water of the Mississippi River. At the height of winter, the upper Mississippi will freeze, further pushing Bald Eagles south into the Upper Mississippi River National Wildlife Refuge. At the convergence of the Chippewa River and Mississippi, just north of the refuge, turbulent waters help to keep the surface from freezing. Water discharge areas

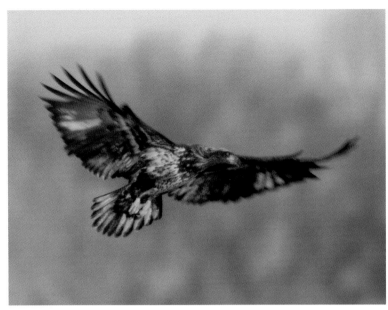

Juvenile Bald Eagle. Nikon D2H Camera, 500mm f/4 lens, 1.4x teleconverter (effectively 1050mm) ISO 400, 1/160 second at f/5.6.

Comeback

Almost driven to the brink of extinction, Bald Eagles have made a steady comeback as a result of conservation efforts and improvements in environmental quality. Also seriously impacted by DDT residue accumulated in fish and hunting, Minnesota Bald Eagles in 1978 totaled a mere 115 active nests. In 2000, this number rose to over 680.

Nationwide bird counts in the continental United States in 2003 have placed the entire population over 100,000. Due to these improvements in breeding and winter surveys, the U.S. Fish and Wildlife Service modified the protection for the Bald Eagle covered under the Endangered Species Act from Endangered to Threatened. This significant accomplishment is a reminder of the importance of clean water and how conservation efforts can restore species on the brink.

from power plants located along the river also help to heat very localized zones. In these sections of water, hundreds of Bald Eagles winter each year, fishing from adjoining ice or trees lining the waterway.

Winter Conditions

• *Cold Conditions.* When shooting in sub-zero temperatures, low-lying fog near the water can blur the subject. To maximize sharpness, let the subject move into an area not affected by the rising heat from the water.

• *Cool Down.* Allow sufficient time for the lens and camera to cool down and reach thermal equilibrium.

• *Returning Indoors.* Cold camera equipment brought into a warm, humid environment will form condensation. Keep your gear in a camera bag or place in a plastic bag to allow it to warm slowly and not come in direct contact with the warm air.

Common Mergansers in-flight. Nikon D2H Camera, 500mm f/4 lens, 1.4x teleconverter (effectively 1050mm) ISO 400, 1/160 second at f/5.6.

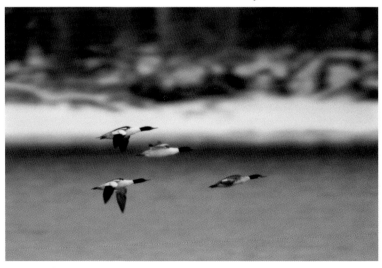

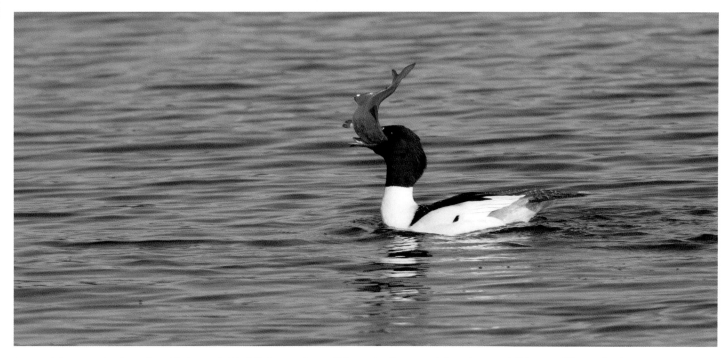

Common Merganser takes down a huge fish. Canon 1D Mark II Camera, 500mm f/4 lens, 1.4x teleconverter (effectively 910mm) ISO 100, 1/640 second at f/7.1.

Freezing Temperatures

Bald Eagle. Nikon D2H Camera, 500mm f/4 lens, 1.4x teleconverter (effectively 1050mm) ISO 400, 1/640 second at f/5.6.

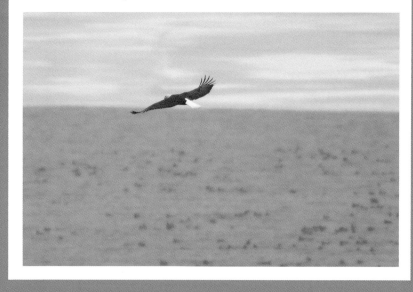

With temperatures hovering below -10 degrees Fahrenheit, water remains open due to turbulence and warm water discharges from power plants. Bald Eagles, Common Mergansers, and numerous other waterfowl scan what open water is left in late February. In these areas, hundreds of waterfowl jockey for fish as Bald Eagles glide overhead.

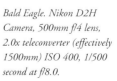

Amidst the fog of a cold winter day, a Bald Eagle silently glides above the open water looking for a fish.

Bald Eagle. Nikon D2H Camera, 500mm f/4 lens, 2.0x teleconverter (effectively 1500mm) ISO 400, 1/500 second at f/8.0.

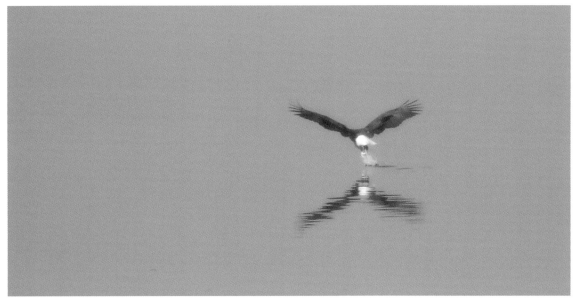

A mature Bald Eagle strikes at a fish. Nikon D2H Camera, 500mm f/4 lens, 2.0x teleconverter (effectively 1500mm) ISO 250, 1/500 second at f/8.0.

Pulling a Fish

A Bald Eagle goes for a fish near the surface of the water. Nikon D2H Camera, 500mm f/4 lens, 1.4x teleconverter (effectively 1050mm) ISO 200, 1/640 second at f/5.6.

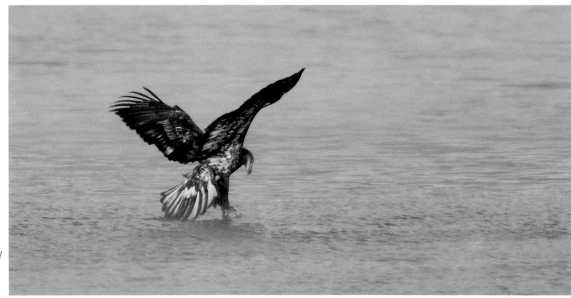

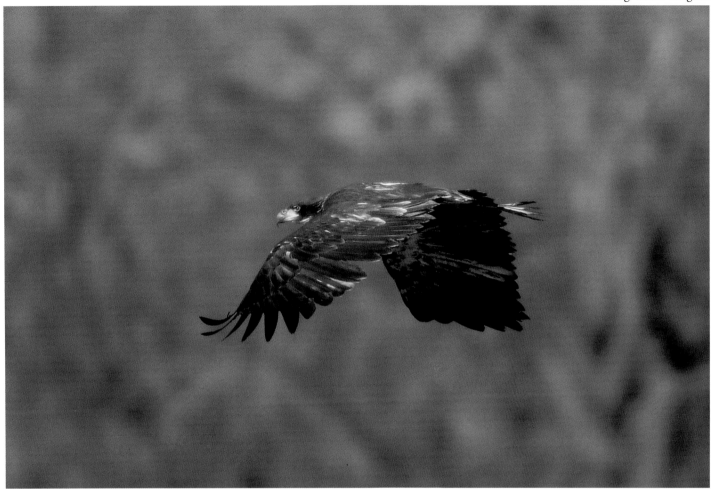

Bald Eagle. Nikon D2H Camera, 500mm f/4 lens, 1.4x teleconverter (effectively 1050mm) ISO 200, 1/1250 second at f/5.6.

Riding the ridgeline along the river, immature Bald Eagles find their first wintering experience productive. Strike after strike, fish are quickly snatched from the water's surface allowing the eagles to maintain a healthy diet during the frigid winter. While powerful and agile, occasionally the fish slips out of the massive claws of the Bald Eagle only to be picked up again by another eagle in close pursuit.

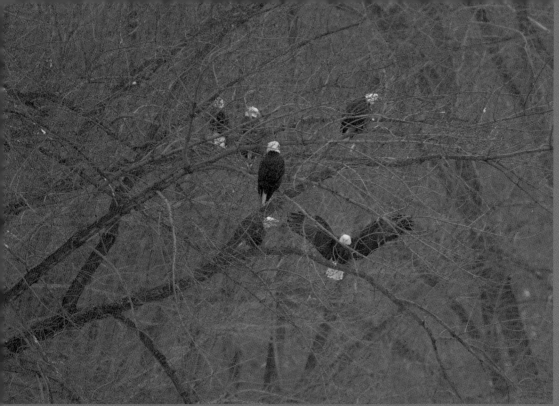

Bald Eagles gather along the open water. Canon 1d Mark II Camera, 500mm f/4 lens, 1.4x teleconverter (effectively 910mm), ISO 1250, 1/500 second at f/5.6.

Fifty to one hundred Bald Eagles often congregate along trees lining the open water. Launching from the trees, the Bald Eagles quickly snatch a fish from the water's surface and then return to the shore to feed.

Low-light Conditions

• *Variable ISO.* Increasing ISO settings in low light conditions allows for stop action photography for birds in flight. Once on the ground or semi-stationary, ISO levels can be lowered to reduce image noise and improve quality.

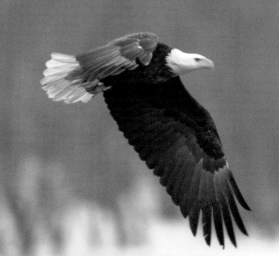

A Bald Eagle launches from the tree line. Canon 1d Mark II Camera, 500mm f/4 lens, 1.4x teleconverter (effectively 910mm), ISO 800, 1/640 second at f/5.6.

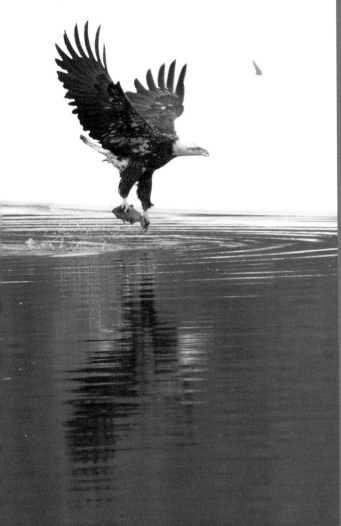

With one claw, the massive Bald Eagle pulls a fish out of the water and lands on the nearby bank. Soon, other Bald Eagles join and a fight ensues over the prey. At the height of winter, this cycle is repeated throughout the day.

As spring starts to edge in, the focus shifts to higher altitude flights, mating, and distribution back north to nesting sites throughout Minnesota, Wisconsin, and Canada.

Bald Eagle snatches a fish from the water. Canon 1d Mark II Camera, 500mm f/4 lens, 1.4x teleconverter (effectively 910mm), ISO 640, 1/640 second at f/6.3.

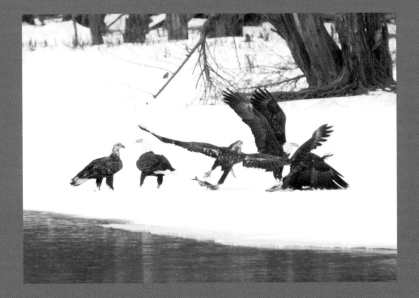

Bald Eagles fight over a fresh catch. Canon 1d Mark II Camera, 500mm f/4 lens, 1.4x teleconverter (effectively 910mm), ISO 640, 1/640 second at f/6.3.

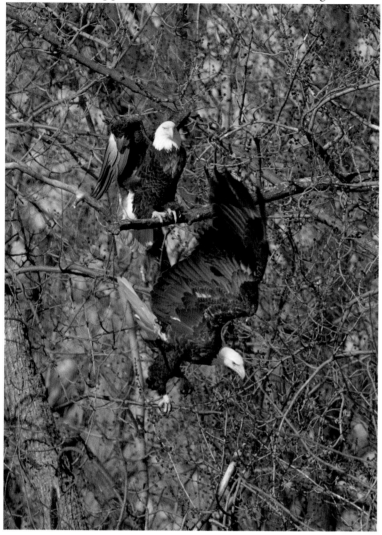

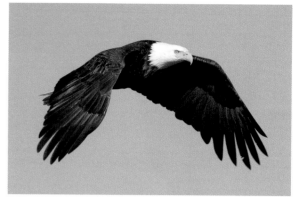

Canon 1D Mark II Camera, 500mm f/4 lens, 1.4x teleconverter (effectively 910mm) ISO 100, 1/800 second at f/6.3.

All along the Mississippi river, hundreds of Bald Eagles are in constant flight searching open water and perching near the shore.

Two Bald Eagles spar for a prime observation post. Canon 1D Mark II lens, 1.4x teleconverter (effectively 910mm) ISO 100, 1/640 second at f/6.3.

National Symbol

A juvenile Bald Eagle lands and takes up position on a tree stump. Canon 1D Mark II Camera, 500mm f/4 lens, 1.4x teleconverter (effectively 910mm) ISO 100, 1/640 second at f/5.6.

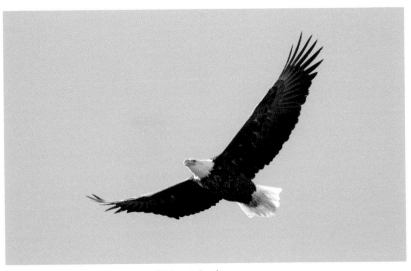

Canon 1D Mark II Camera, 500mm f/4 lens, 1.4x teleconverter (effectively 910mm) ISO 100, 1/800 second at f/7.1.

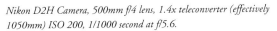

Nikon D2H Camera, 500mm f/4 lens, 1.4x teleconverter (effectively 1050mm) ISO 200, 1/1000 second at f/5.6.

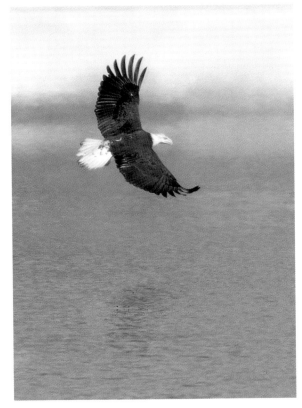

Nikon D2H Camera, 500mm f/4 lens, 2.0x teleconverter (effectively 1500mm) ISO 200, 1/500 second at f/8.0.

Nikon D2H Camera, 500mm f/4 lens, 1.4x teleconverter (effectively 1050mm) ISO 200, 1/640 second at f/5.6.

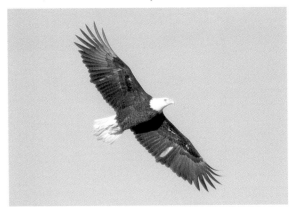

Stewards of the Land

Prior to mankind's population of the land, bird migration was throttled exclusively by environmental factors. Swings in global climate changes, droughts, above average wet seasons, food sources, and disease all affected bird populations and distributions.

Today, millions of acres of land have been converted into urban developments, farms, roads, and industrial uses. Reductions in the boreal forest that surrounds the northern hemisphere of the earth, loss of pristine lakes, and disruption of centuries old migration routes have affected migratory birds and continue to be a threat.

As our Nation and that of others has grown, actions have been taken to protect key wildlife species and the lands necessary to support them. From Dr. Paul Bartsch's first study on migratory birds until now, our presence on this land has disrupted key migration flyways and brought species like the Bald Eagle, Trumpeter Swan, and others to the brink of extinction. While we have been successful in saving certain species, others have not been so successful.

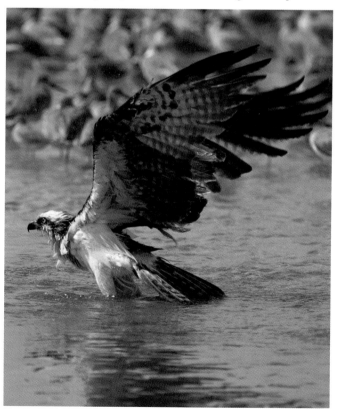

Once one of the most abundant birds on earth, the Passenger Pigeon approached populations in the billions in the 19th century. Huge swarms a mile wide and 300 miles long would darken the sky for hours during migration. Over-hunting, no protection, and an exploding agricultural base cleared essential forests and habitat. The last nesting bird was found in the Great Lakes around 1890. Years later, in a Cincinnati zoo on September 1, 1914, the last known Passenger Pigeon died. Today, the species is extinct.

Our National Wildlife Refuge system is serving a critical role in the restoration of endangered and threatened species. Through the active management of 540 refuges and 95 million acres, numerous birds, waterfowl, and migratory species have a chance to winter in unpolluted land, free from over-hunting and disruption of habitat.

While there are many success stories, our National Wildlife Refuge system cannot exist as an island. Cross-continental and inter-agency cooperation are essential as migrating birds can travel great distances and cross many jurisdictions. Refuges such as the Bosque del Apache, J.N. "Ding" Darling, Sherburne, and Upper Mississippi River are microcosms of conservation and environmental success. They all share a common theme of lost resources due to development, species thrust on the brink of extinction, and an amazing comeback of environmental resources and protection.

The resources provided by the US Fish and Wildlife Service, US Geological Survey, and other agencies not only help to protect and conserve key species, they also conduct critical monitoring. Trend analysis, mortality rates, administration of hunting regulations, and assessment of agricultural practices tie together protection of key species with actively managed conservation.

Without this active management, it is quite possible that efforts to protect key species could do more harm than good. An excellent example is the North American light geese. With geometric population growth, if left unchecked this species could reach Biblical

populations that cannot be supported by reduced habitat and may result in an eco-system crash of the species. Not only do these huge populations spread avian cholera and other diseases, they also can impact other birds and humans.

Through these studies of the environment, we know much more about migratory patterns than ever before and conditions that influence survival. Humans, even in the 1800's, had the power to completely wipeout a billion Passenger Pigeons in 100 years. Prepared with this information, we as stewards of the land have a responsibility to ensure that our environment and the species on it prosper for generations.

Without the active stewardship of the land, images such as those within this book may one day be a thing of the past. Today, digital photography is merely a tool much like the paintings of John James Audubon in the 1800's, or the cartoons of J.N. "Ding" Darling as a way to illustrate the wonderful lands we have been entrusted by our Creator. Without active stewardship at all levels, digital nature and wildlife photography could have a very limited future.

About the Author

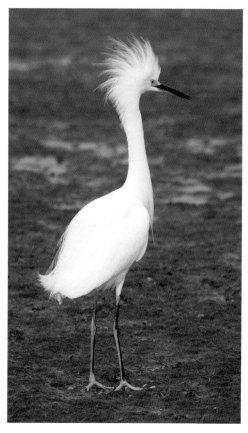

At the nexus of digital technology and wildlife photography is the Canon 1D Mark II digital SLR camera. With 8 megapixel resolution and 8.5 frames per second frame rate, this camera was the first to cross a critical barrier in digital photography. The advancements of the 1D Mark II has truly enabled high resolution photography with astonishing speed and excellent exposure balance - perfect for fast action bird photography. This advancement, coupled with image stabilization and long focal length lenses now allows the intricate behaviors of birds to be uncovered like never before.

While I still reach for film cameras for landscape photography, my transition to digital bird photography is complete. For now, this medium represents the best tool to reveal issues facing migratory birds and conservation issues in a format that can be communicated like never before. Soon, these advancements in resolution, autofocus, and image control will be surpassed by other technologies. Just like in Audubon's day however, it's not the medium, but the power of the message.

When I entered college, I had ambitions of a career in petroleum geology. My interest was in exploration. This desire came out of my natural interest in the environment, science, and long days spent exploring the Indiana Dunes National Lakeshore. After a few semesters I transferred into engineering focusing more on my technical skills, a career I have been fortunate to enjoy for many years. However, I still long for the thoughts of exploring our environment and uncovering the mysteries of geology.

During my career as an engineer I was awarded numerous US Patents and participated in a number of design efforts for some of the world's most advanced systems and programs. With all of that focus on the technical, I've still held close an interest in developing and using my artistic skills. First as a hobby and then professionally, photography has consumed my thoughts. I have had numerous personal and corporate clients over the years and have had my work featured in a number of photographic contests, magazines and newspapers.

In 2003, I produced my first book featuring my photography, *Bosque del Apache National Wildlife Refuge, 48 Hours of Flight*. This book, devoted exclusively to the refuge, documents my first experiences over a 48 hour period. The book has been recognized in a number of magazine and newspaper reviews, and by the Midwest Independent Publishers Association. The book was shot entirely with a 35mm film camera.

A year later I published a second book *Our National Parks and Wildlife Refuges, Capturing the Rhythms of Light and Land*. This book unravels the natural rhythms of the land through photographic techniques and conservation/preservation issues. Using a mix of 35mm and medium format films, some of our most cherished national parks and refuges are explored. The book was recognized by the 2004 International Photographer of the Year Awards, and numerous other awards and reviews.

Both books were published by ImageStream Press, a company I founded in 2003 to capture the rhythms of our great national parks and wildlife refuges on film and digital imagery. Our only focus is to bring light to the benefits of conservation and preservation of natural resources.

Publishing a book can be a daunting task but absolutely

enjoyable. Conducting the research, visiting wonderful locations, photographing unbelievable views, and putting together the concept is the ultimate in creative freedom.

In the publishing business, here again digital is playing a significant role and advancing rapidly. All three of my books have been printed using a Computer To Plate technology, also known as CTP. In this process, digital images are used to create first generation printing plates. By eliminating film traditionally used in the printing process, CTP offers enhanced resolution direct from the original image. With the advent of high resolution digital cameras, it is now possible to bypass 35mm film to digital scanning, further shortening the development time. Now digital images can go direct into a document editing tool such as Adobe InDesign, to a PDF, and then to press without ever being scanned or put on film.

With all this advancement in technology, here I am again publishing another book on the environment, now completely digital. I guess in some way I've never really left my roots in the environment, exploration, and technology. Photography is a way for me to reconnect with the environment and unravel the past through the rhythms of light and land.

I have had the opportunity to not only visit a number of our key and sometimes overlooked national resources, I've also had the chance to work with really great photographic equipment. The majority of my landscape photographic work has been accomplished with a medium format camera. Four times larger than 35mm, and significantly heavier, medium format offers a capability I simply cannot achieve with 35mm or digital. I notice this most readily when looking through the huge viewfinder. This allows me to see the environment much as I see the world, composing images I often struggle with using 35mm or digital.

When I am photographing wildlife, a digital SLR is by far and away the ticket. For years I have utilized a Nikon D2H, and now a Canon 1D Mark II, with a 500mm f/4 lens. This, coupled with 1.4x teleconverter, allows me to achieve an unbelievable 910mm capability.

At 8.5 fps, it is easy to collect a huge number of images. For just the Bosque del Apache NWR section of this book, I took over 5,000 images. Returning to the refuge armed with the latest in digital was like walking through the pages of my first book at the speed of light. However, this time

it was substantially different as the days of analog were left behind.

The ability to review images in the field as events were unfolding and later in the evening not only helped me see how to better adjust exposure and composition, it also helped me better understand and tie together events as they were happening instead of weeks later.

While there are significant technical issues to be resolved, such as reliable storage for thousands of electronic images over a career, digital photography allows me to achieve something I never considered before. That is, the ability to peer into a world that otherwise would be impossible to participate in. Through real-time digital photography it is possible to resolve the details of birds and how they interact, fly with cranes, and see and print the world with incredible color.

Photography has allowed me the opportunity to blend my creative, technical, and environmental interests. I look forward to many more years of capturing the wonders of our national parks and wildlife refuges for generations to enjoy.

References

Migration Corridors, United States Geologic Survey, Patuxent Wildlife Research Center.

Moser, T.J., editor. 2001. The status of Ross's geese. Arctic Goose Joint Venture Special Publication. U.S. Fish and Wildlife Service, Washington, D.C., and Canadian Wildlife Service, Ottawa.

Alisauskas, R.T. 2001. Species description and biology. Pages 5-9 in T. J. Moser, editor. The Status of Ross's geese. Arctic Goose Joint Venture Special Publication. U.S. Fish and Wildlife Service, Washington, D.C., and Canadian Wildlife Service, Ottawa, Ontario.

Sharp, D.E., J.A. Dubovsky and K.L. Kruse. 2004. Status and harvest of the Mid-Continent and Rocky Mountain Populations of sandhill cranes. Unnumbered. Administrative Report. U.S. Fish and Wildlife Service. Denver, Colorado 8pp.

U.S. Fish and Wildlife Service. 2003. Waterfowl population status, 2003. U.S. Department of the Interior, Washington, D.C. 53pp.

U.S. Fish and Wildlife Service. Trumpeter Swan population status, 2000. U.S. Department of the Interior, Washington, D.C. 15pp.

U.S. Fish and Wildlife Service. 2004. Waterfowl population status, 2004. U.S. Department of the Interior, Washington, D.C. U.S.A.

Kruse, K.L. Central flyway harvest and population survey data book 2004. U.S. Fish and Wildlife Service. Denver Colorado. 78pp.

Batt., B.D. J., editor 1998. the greater Snow Goose: report of the Arctic Goose Habitat Working Group. Arctic Goose Joint Venture Special Publication. U.S. Fish and Wildlife Service, Washington D.C. and Canadian Wildlife Service, Ottawa, Ontario. 88pp.

U.S. Fish and Wildlife Service. Arctic Ecosystems in Peril: Report of the Arctic Goose Habitat Working Group. U.S. Department of the Interior, Washington, D.C. U.S.A.

Taylor, J.P., A Plan for the Management for Waterfowl, Sandhill Cranes, and other Migratory Birds, New Mexico Department of Game and Fish. U.S. Fish and Wildlife Service, APHIS-Wildlife Services, New Mexico District, 50pp.

Mitchusson, T., Long-Range Plan for the Management of Sandhill Cranes in New Mexico 2003-2007. New Mexico Department of Game and Fish. Wildlife Division, Santa Fe, NM, 41pp.

Anonymous. No date. Wood Duck (Aix sponsa). U.S. Department of Agriculture, Natural Resources Conservation Service, Madison, MS, and Wildlife Habitat Council, Silver Spring, MD. Fish and Wildlife Habitat Management Leaflet. Jamestown, ND: Northern Prairie Wildlife Research Center Online. http://www.npwrc.usgs.gov/resource/1999/woodduck/woodduck.htm

U.S. Fish and Wildlife Service. Final Environmental Impact Statement, Double-crested Cormorant Management in the United States. 2003. U.S. Department of Interior, Washington, D.C. 208pp.

Wires, L.R., F.J. Cuthbert, D.R. Trexel and A.R. Joshi. 2001. Status of the Double-crested Cormorant (*Phalacrocorax auritus*) in North America. Final Report to USFWS.

Richard Baker, Joan Galli, and Sharron Nelson, 2000 Minnesota Bald Eagle Survey, Minnesota Dept. of Natural Resources December 2000.

Special thanks to Colin Lee of the Bosque del Apache National Wildlife Refuge.

Other books by Jim Jamieson:

Our National Parks and Wildlife Refuges, Capturing the Rhythms of Light and Land, ISBN 0-9729126-1-4.

Bosque del Apache National Wildlife Refuge, 48 Hours of Flight, ISBN 0-9729126-0-6.

Jim Jamieson photography is available for stock and advertising use and limited edition prints. For more information contact ImageStream Press.